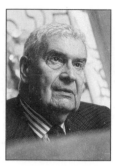

FEDERICO ZERI (Rome, 1921-1998), eminent art historian and critic, was vice-president of the National Council for Cultural and Environmental Treasures from 1993. Member of the Académie des Beaux-Arts in Paris, he was decorated with the Legion of Honor by the French government. Author of numerous artistic and literary publications; among the most well-known: *Pittura e controriforma*, the Catalogue of Italian Painters in the Metropolitan Museum of New York and the Walters Gallery of Baltimora, and the book *Confesso che ho sbagliato*.

Work edited by FEDERICO ZERI

Text
based on the interviews between
FEDERICO ZERI and MARCO DOLCETTA

This edition is published for North America in 1999 by NDE Publishing*

Chief Editor of 1999 English Language Edition
ELENA MAZOUR (*NDE Publishing**)

English Translation
RAMAN A. MONTANARO

Realisation
CONFUSIONE S.R.L., ROME

Editing
ISABELLA POMPEI

Desktop Publishing
SIMONA FERRI, KATHARINA GASTERSTADT

ISBN 1-55321-001-8

Illustration references

Alinari archives: 1, 2-3, 4, 5, 6-7, 8, 9, 10c, 17r, 22b, 24, 25, 28, 29l-r, 30, 31tr, 43b, 44/VII-IX, 45/III-IV-V-VIII-IX, 46.

Luisa Ricciarini Agency: 11t, 16br, 17c, 23br, 36-37, 41cr, 44/III, 45/II.

RCS Libri Archive: 14t, 16tl-bl, 16-17, 18, 19 tl-tr, 20, 21, 22t, 23t-bs, 26, 27b, 31bl-br, 34-35, 35t-c 38-39, 44/IV-V-VI-X-XI, 45/VI-VII-X-XI-XII-XIII-XIV.

R.D.: 2, 10t-b, 11bl-br, 12-13, 14b, 14-15, 19b, 27t, 31 tl, 32, 33, 35b, 40, 40-41, 41, 42, 43tl-tr, 44/I-II-VIII-XII, 45/I.

Printed and bound by Poligrafici Calderara S.p.A., Bologna, Italy

* a registred business style of NDE Canada Corp.
 18-30 Wertheim Court, Richmond Hill, Ontario
 L4B 1B9 Canada, tel. (905) 731-12 88

The captions of the paintings contained in this volume include, beyond just the title of the work, the dating and location. In the cases where this data is missing, we are dealing with works of uncertain dating, or whose current whereabouts are not known. The titles of the works of the artist to whom this volume is dedicated are in blue and those of other artists are in red.

REMBRANDT
SUPPER AT EMMAUS

The luministic Caravaggesque experience moves to Holland, and finds new accents of light and color in this SUPPER AT EMMAUS, in the boldness of a transverse composition that places Christ in backlighting, treating

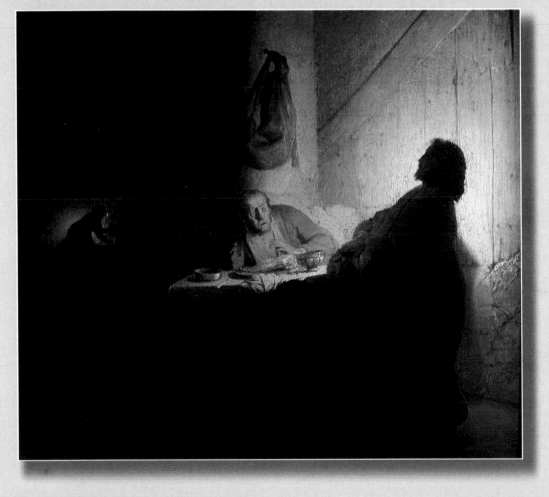

him almost as a pure silhouette. Low in the foreground, the half-light is hiding the second disciple, in an apparent iconographic anomaly.

Federico Zeri

...THEN CAME THE LIGHT

SUPPER AT EMMAUS

1629

● Paris, Musée Jacquemart-André (oil on paper applied to wood, 42x37.4cm)

● This small painting was done in 1629 by Rembrandt in Leiden, in a period in which he had many exchanges of ideas with the painter Jan Lievens.

● In Leiden, in 1626, the painter Joannes Wtenbogaert arrived from Utrecht, where he had learned the new use of light from the most well known popularizers of the art of Caravaggio in Holland. The youthful Lievens and Rembrandt, taken in those years by the most varied coloristic and luministic experimentations, welcome the studies on the new ways of rendering light with great interest, and begin to paint in the style of Gerard van Honthorst – known in Italy as Gherardo of the Nights – scenes immersed in a dream-like nocturnal light.

● While Lievens is specializing in half-figures in the foreground, interpreted through the light, Rembrandt prefers the whole figure, and uses even the background in his search for spacial depth.

● The curiosity of this little picture lies first of all in the material of which it is made: the subject is painted in oil on paper – instead of on canvas – later applied to a surface of wood. In the second place, the particular luministic choice is striking: the artist exploits the pictorial space as dramatic space, and the blinding light, which, even though coming from the figure of Christ, illuminates him from behind, augmenting the sensation of astonishment and tension which is created in the surrounding atmosphere.

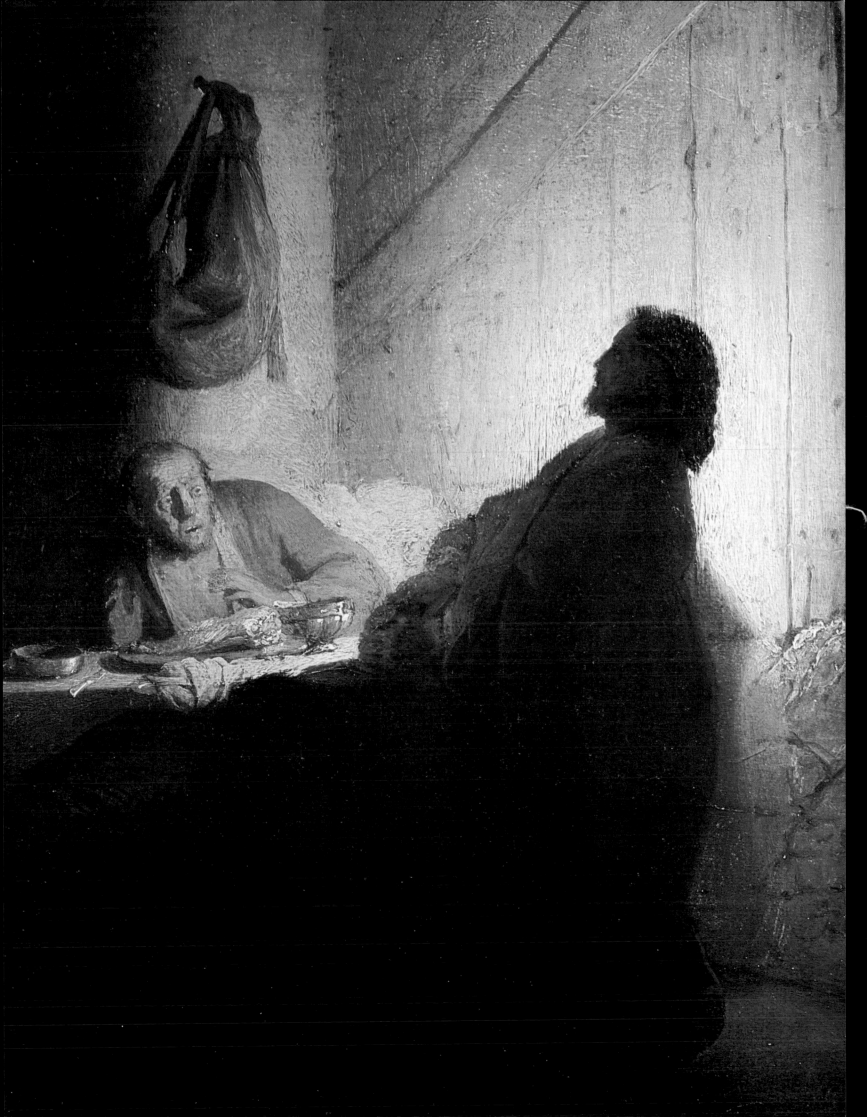

FROM SHADE TO LIGHT

The lesson of Caravaggio arrives in Holland through a dense network of cultural exchanges which witnessed many northern painters staying temporarily in Rome in the first decades of the 17th century, and Italian artists staying in foreign courts. Not to mention the considerable importance of the circulation of the new artistic trends in the schools and studios, sometimes very far from the place where they originated, thanks to the entrepreneurial activity of art dealers on behalf of collectors.

● Caravaggio thus had great importance in the formation and artistic development of the young Rembrandt. The intermediary was the school of Utrecht, the most serious of the second decade in teaching the new conception of light of the Italian master.

● The violent light which rolls over people and things in the pictorial space is absolutely not natural: it is a symbolic light, a divine emanation. It illuminates the action, and puts it into motion, unveiling its feeling.

● Rembrandt effects a special treatment of the darkness surrounding the scene. It is never total, it is a modulated, inhabited half-light to which is entrusted the responsibility of providing spacial depth to the scene in which it occurs.

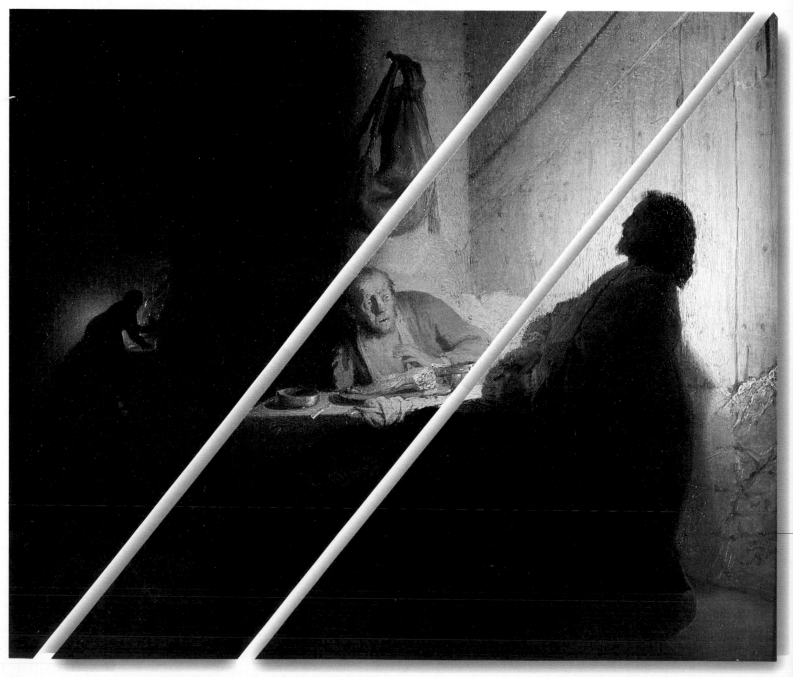

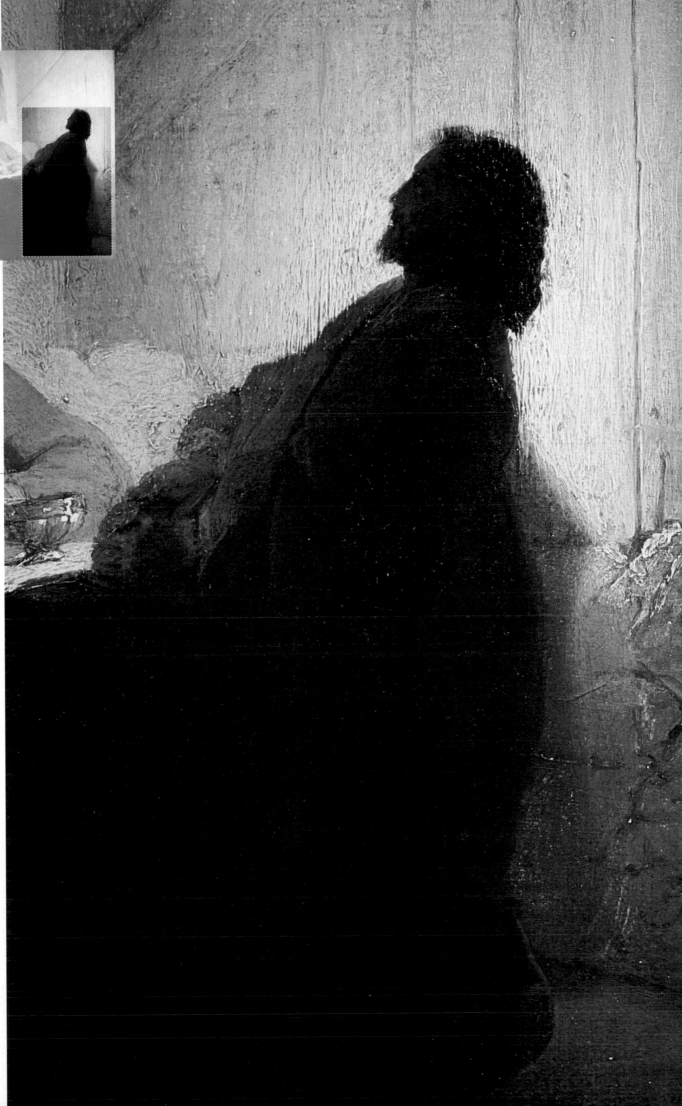

♦ THE SHADOW MAKES
LIGHT

It is an altogether
unnatural light placed
by Rembrandt on the
far side of Christ:
a light which is divine
illumination, and as
such can only come
from his own figure.
The sudden and violent
light which irradiates
the scene puts Jesus in
backlighting, in profile,
in a dramatically
portrayed position.
At his feet, kneeling
before the revelation of
the divine Presence, is
the second apostle.
It is necessary to
rummage in the dark
with your eyes to find
him, accustomed as we
are from classical
iconography to see the
two apostles seated
together at the table.

♦ DIAGONALS AND
SILHOUETTES
Baroque art often falls
back on formal
solutions for strong
tension: in this case
they are the double
diagonals and the
treatment in silhouette
of the figures
in the foreground
and background
to create a dramatic
effect, and at
the same time
to suggest the sense
of sudden, divine
illumination.

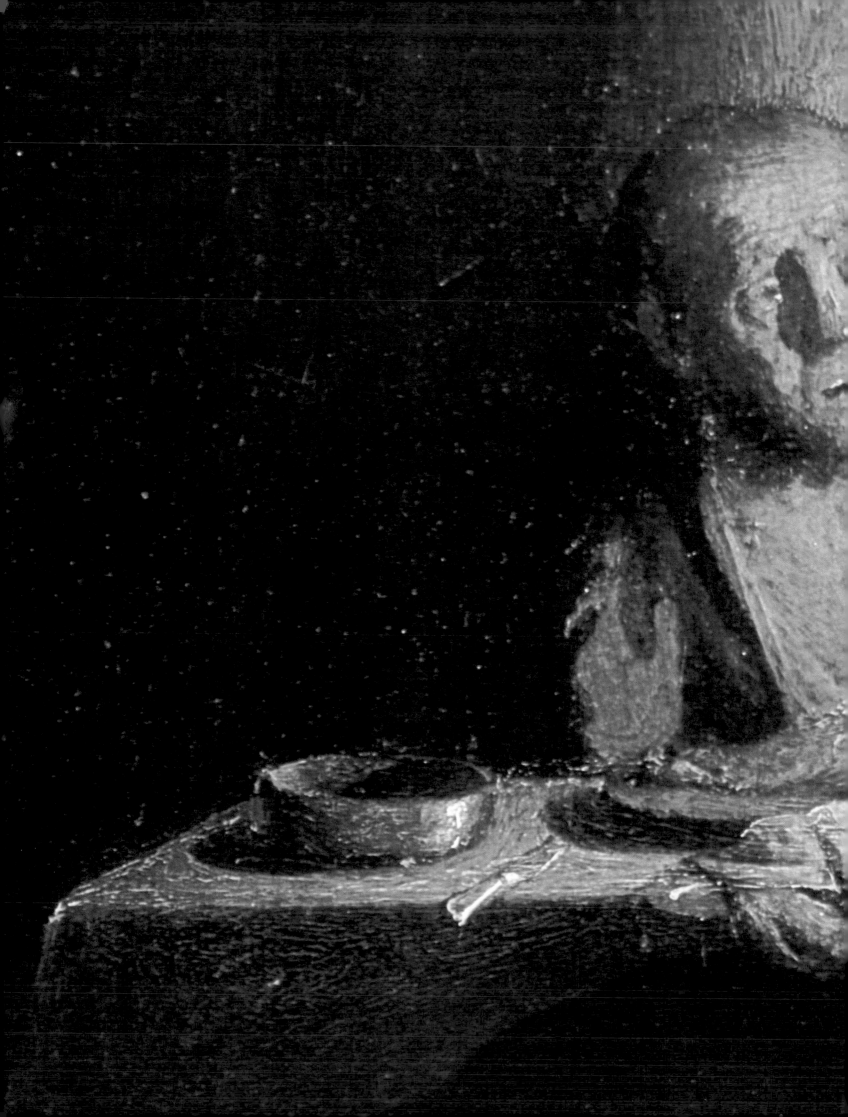

◆ ASTONISHMENT
The blinding light beats
on the apostle, who
withdraws, afraid,
dazzled and intimidated
by the sudden
revelation: it is not a
simple traveler who is
seated next to him.
In the end, he
recognized him by the
way in which he broke
bread during the
supper, according to
the reference by Luke
in his Gospel, which
Rembrandt carefully
follows in the creation
of the scene.
The light points out
the humble furnishings
on the table, and the
peeling wall of the
modest surroundings
in which the episode is
taking place.

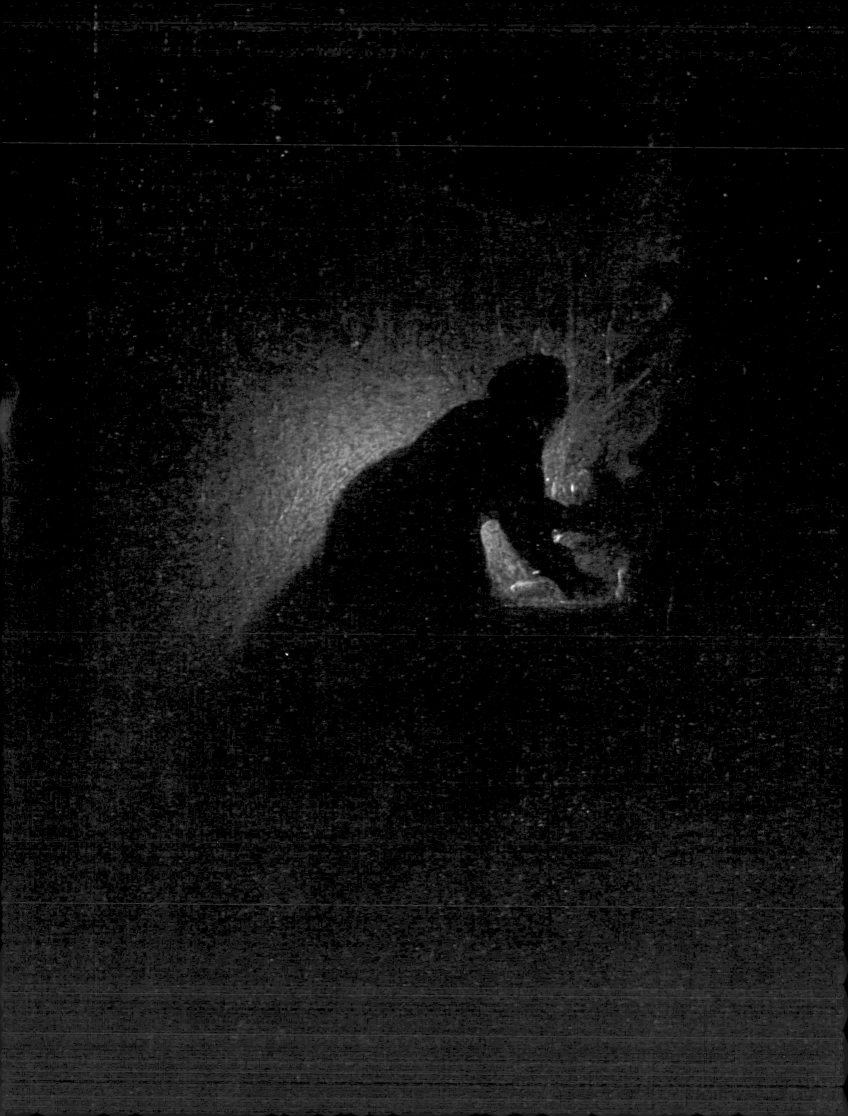

◆ DEPTH
Rembrandt often uses
the dark background
to pursue the effect
of depth in the scene.
The backlit figure
of the woman, intent
on washing up in the
kitchen, has a function
of this type, not finding
any reference in the
evangelical narrative:
it suggests a sense
of depth, and makes
a companion for
the other backlit figure
in the foreground.

◆ THE SACK OF THE
TRAVELER
The detail, treated with
naturalistic flavor,
serves the narration:
it constitutes an
attribute of the figure
of Christ, who has
assumed the semblance
of a traveler in the
evangelical episode.
As such, he
accompanies the two
apostles along the road,
and with the fall
of night, is invited
to stop with them,
and retake the road
on the morrow.

AN ILLUSTRATED BIBLE

After a stay of three years in the studio of Iacob Isaacsz van Swanenburgh, in whose care the adolescent Rembrandt learns the rudiments of the career, he comes to meet the much more famous painter Pieter Lastman. His school will be decisive for the choices of the youthful painter, who will learn to treat above all Biblical and historical themes, favorites of the master.

● In the years following his return to Leiden, Rembrandt develops a love for representing scenes taken from the sacred history, of which he demonstrates his knowledge in the smallest details. Some of these have no iconographic precedent, while others follow a more traditional treatment.

● Rembrandt depicts the *Supper at Emmaus* several times, at different moments of his artistic career: the first time in the little painting in Paris; again, in 1648, in two versions: one conserved at the Louvre, the other in Copenhagen. Finally in 1660 in another painting, about whose autograph there is still debate, this also exhibited at the Louvre.

● The story of *Supper at Emmaus*, as narrated in the Gospel of Luke (Luke 24:13-31), is also treated in two very different engravings, one from 1634 and the other from 1654.

● In the extraordinary painting in the Louvre, from 1648, the protagonist is no longer only the light, but the deep and mysterious sense of the miracle, to which all the figures are participants, except that of the servant in the background, who doesn't recognize in the central figure the Resurrected One, and brings a dish on a tray, unaware of the event that is unfolding around him.

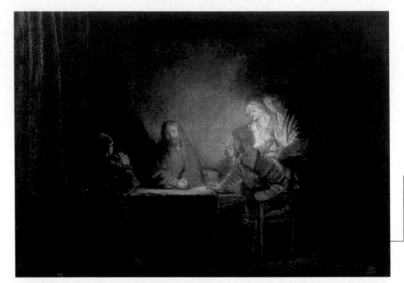

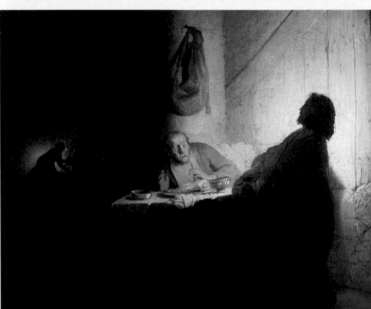

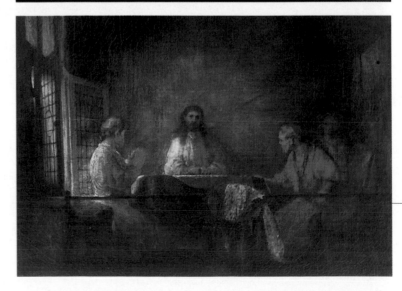

◆ **SUPPER AT EMMAUS (1648, Paris, Louvre).** The setting of stone in which the scene unfolds is very different from that of 1629. Jesus is seated in front of a deep and wide niche, like an apsidal space. The table is set like an altar. Everything recalls a church in which the Eucharistic mystery is celebrated.

◆ **SUPPER AT EMMAUS (1648, Copenhagen, Staatens Museum for Kunst).** The figure of Christ replicates that of the Louvre – in its turn inspired by that of Leonardo in *The Last Supper* – while the other persons place themselves in a dark and faintly characterized setting.

◆ **SUPPER AT EMMAUS (1629, Paris, Musée Jacquemart-André).** A precedent which perhaps furnished the inspiration for the painting is the *Philemon and Baucis* by Elsheimer, known through an engraving by Goudt. But Rembrandt re-elaborates the idea with such force as to impress everyone with his boldness and freedom from prejudice.

◆ **SUPPER AT EMMAUS (1660, Paris, Louvre).** In a late version Rembrandt once again deals with the same theme, with a formal solution that takes into account the preceding elaborations and sets them in a new creation.

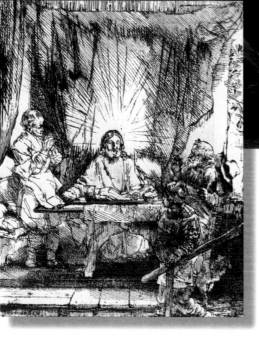

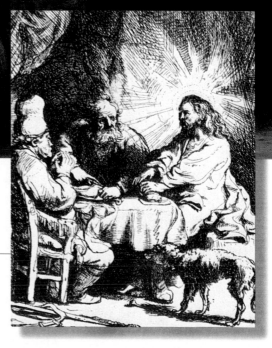

♦ CHRIST IN EMMAUS
(1654, engraving,
Berlin, Staatliche
Museen Preussischer
Kulturbesitz). The
engraving re-elaborates
the painting of 1648,
with some variations:
a canopy frames the
figure of Christ, and the
setting is modest.

♦ CHRIST IN EMMAUS
(1634, engraving,
Berlin, Staatliche
Museen Preussischer
Kulturbesitz).
The engraving shows
a change of mind
in the figure
of a servant, first
inserted, then covered
by a thick hatching.

POISED BETWEEN GLORY AND RUIN

Success smiles on the young Rembrandt rather quickly, admired and encouraged by distinguished men of culture and noticed by Constantijn Huygens, secretary to the Prince of Orange, Frederick Henry, his enthusiast, to the point of commissioning him with the cycle of paintings of the *Passion*. He travels much between l'Aja, Leiden, Amsterdam and other cities, asserting himself as the best portrait painter of the local middle-class high society.

● His meeting in 1631 with Hendrick Uylenburgh, Polish art dealer, Mennonite, rich and enterprising, signals another positive turn for his life. He marries Saskia, holder of a sizable dowry; he is continually requested for his artistic services. He has a studio packed with young men, earns well and is a member of the Guild of San Luca.

● Himself a dealer and collector, he refuses to go to Italy, according to the same Huygens' suggestion, to come to know the works of Michelangelo and Raphael directly. In reality, thanks to his splendid collection and to his activity as a dealer, Rembrandt often comes into contact with the paintings of the great masters.

● At the apex of his career, when he paints the *Night Watch* in 1642, the artist's affective and economic instability insinuates itself. His beloved Saskia dies, leaving him an infant son, Tito; the wet nurse with whom he lives for several years denounces him when she sees her role threatened by Hendrickje, young and beautiful model. The puritanical Dutch society turns its back on him. The scandal grows when Hendrickje gives him a daughter, Cornelia. The favor of the public turns elsewhere. Financial difficulties force him to reduce his style of life and to put up for auction part of his wealth. But his studio continues until the end to produce masterpieces extraordinarily rich in humanity.

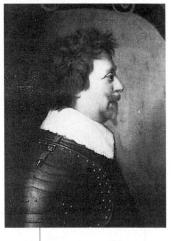

THE MENNONITES

The Mennonites are a presbyterian and anabaptist sect which doesn't recognize any type of priesthood, only admits the elders to serve as counselors or teachers, and only baptizes adults. In addition, it recognizes the Bible as the only source for the doctrine of the faith. It proposes to purify the society, and has as its model the protochristian community. The faithful are called to act rightly and do good. After the persecutions, the Mennonites isolate themselves, and refuse both military service and public office. In time, they abandon their isolation and dedicate themselves to business and cultural activities, only externally keeping a certain simplicity in their dress. The Mennonite community of Amsterdam in the 1600's is rather numerous.

◆ GERARD VAN HONTHORST
Portrait of Frederick Henry (1631, L'Aja, Huis Ten Bosch). Last son of William of Orange, he had his castle decorated by famous artists, and enriched his collection following Huygens' advice.

◆ PORTRAIT OF MARTEN LOOTEN (1632, Los Angeles, County Museum of Art). Rembrandt painted numerous portraits of Mennonites. This was a well-to-do merchant of Amsterdam.

◆ SELF-PORTRAIT WITH PALETTE AND BRUSHES (1661 ca., London, Kenwood House, Iveagh Bequest). The master paints himself with the instruments of the trade that have brought him fame and success. No other artist has ever painted as many self-portraits as Rembrandt. Alone or in a group, or even semi-hidden in the crowd, his figure is always present, as if the painter wanted to fix once and for all a certainty, a stability, that continually eludes him.

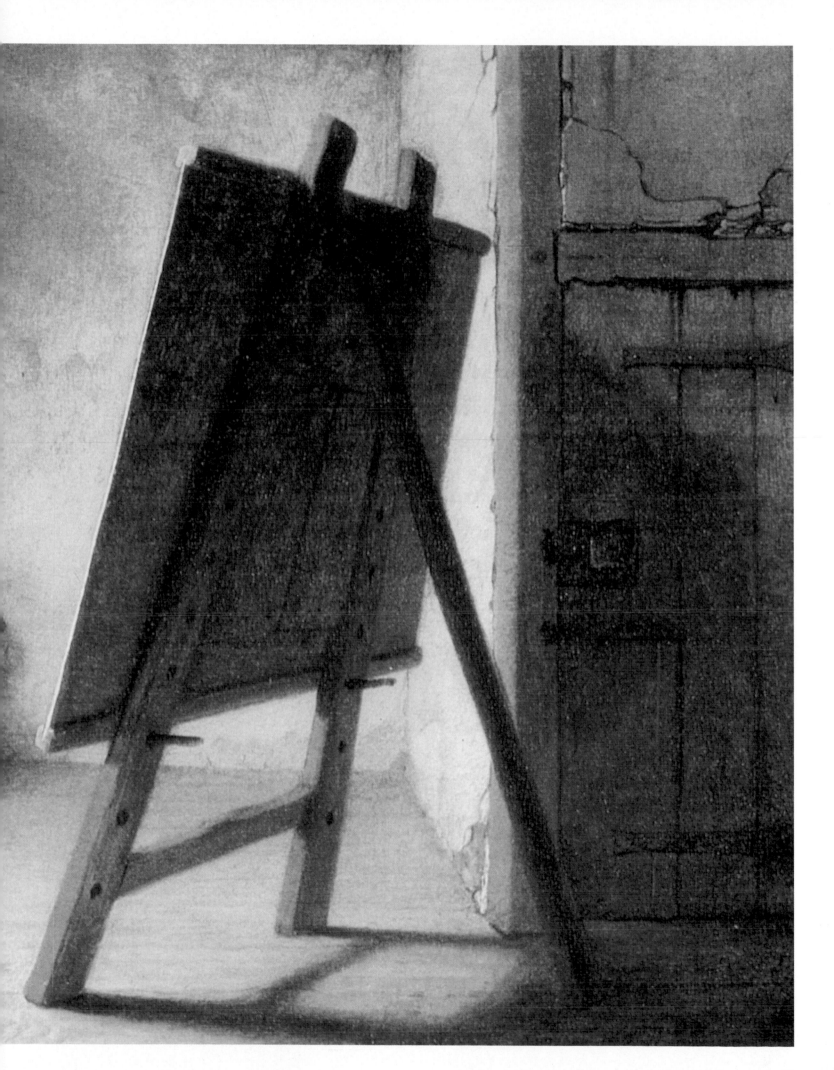

PORTRAITURE

The ambitious, successful merchant middle class, the exponents of the various religions that live together in a spirit of total toleration in the Low Countries, the public servants, the captains of companies, aspired to be commemorated and immortalized by the portrait, which represented a status symbol for them. Portraiture was thus a dominant genre and had its *raison d'etre* in the historico-sociological dynamic of that age.

● Rembrandt's merit does not lie therefore in having introduced or developed a genre, but in having changed the rules of the tradition, transferring to the portrait the developments in painting from history, and innovating its classical poses.

● All this is evident in the group portrait which, until the time of the master, lined up the portrayed personages one next to the other, forming a kind of rather flat gallery.

● Rembrandt practices the self-portrait throughout his life, more than sixty times: he uses it as a way of cognitive investigation – using for this goal a model always within reach – and for capturing states of being, disguises, contrasts, allusions.

◆ ANATOMY LESSON OF DOCTOR TULP (1632, L'Aja, Mauritshuis).
The guild of surgeons in Amsterdam entrusts the painter with the important responsibility of representing the annual anatomy lesson in a painting. It is one of the artist's first attempts in the field of group portraiture.
The composition is highly innovative, be it for the attitude of the seven people, which is no more immobile and solemn, or be it for the study of their expressions, which no longer presents anything of the static and conventional.

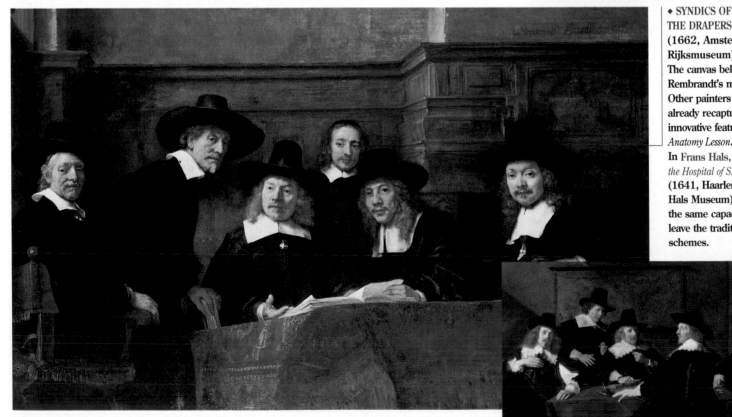

◆ SYNDICS OF THE DRAPERS' GUILD (1662, Amsterdam, Rijksmuseum).
The canvas belongs to Rembrandt's maturity. Other painters have already recaptured the innovative features of the *Anatomy Lesson*.
In Frans Hals, *Regents of the Hospital of S. Elisabetta* (1641, Haarlem, Frans Hals Museum), there is the same capacity to leave the traditional schemes.

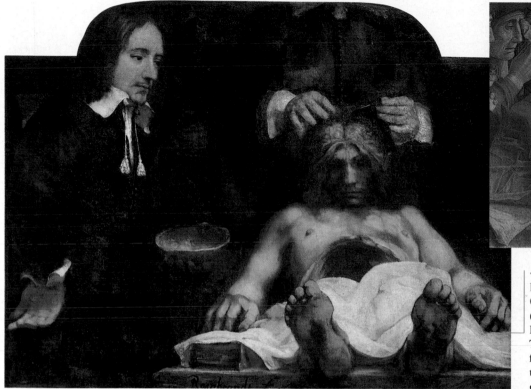

♦ THE ANATOMY
LESSON
OF DOCTOR DEYMAN
(1656, Amsterdam,
Rijksmuseum).
The iconographic debt
for the dead body seems
to be that of *Dead Christ*
of Andrea Mantegna
(1480, Milan, Brera
Picture Gallery),
to mean that even
a sinner is created in the
Divine Image. Only the
bodies of the executed
were in fact dissected
during these masterful
anatomy lessons.

♦ PORTRAIT OF AGATHA
BAS
(1641, London,
Buckingham Palace).
Agatha Bas belongs to
the Dutch upper-middle
class. For this painting,
Rembrandt breaks
through the space,
masterfully turning
to a *trompe-l'œil* device
already seen in Frans
Hals: the woman rests
her hand on the mock
frame of the painting,
cut by the open fan.
The subject seems to
step out into full light
from surroundings
immersed in semi-
darkness.

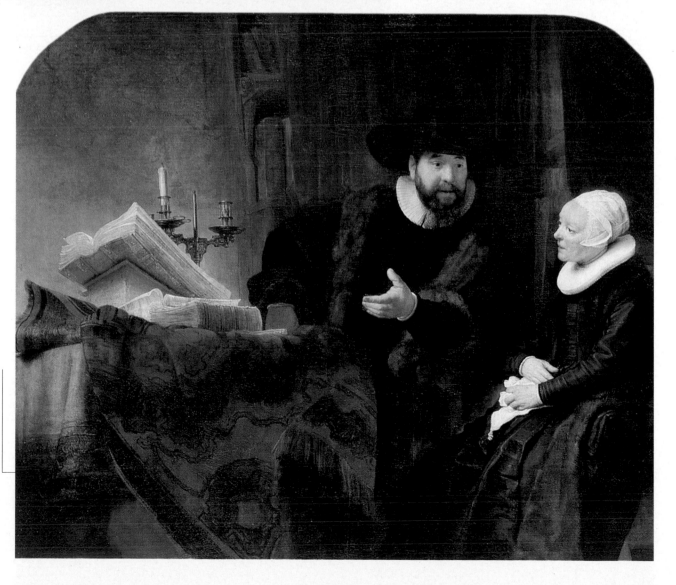

♦ PORTRAIT OF
CORNELIS CLAESZOON
ANSLO AND HIS WIFE
(1641, Berlin-Dahlem,
Staatliche Museen,
Preussischer
Kulturbesitz).
In this double portrait,
the painter preferred
to capture a moment
typical of the existence
of the couple,
portraying it in the
intimacy of the home.

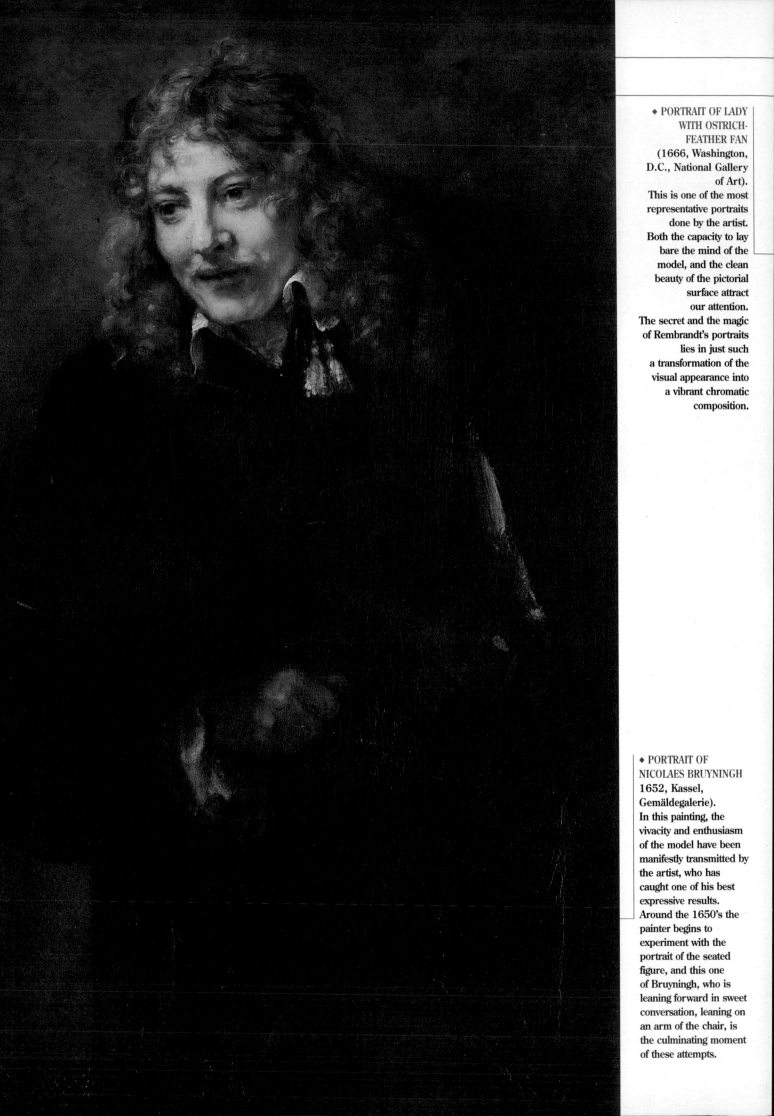

◆ PORTRAIT OF LADY
WITH OSTRICH-
FEATHER FAN
(1666, Washington,
D.C., National Gallery
of Art).
This is one of the most
representative portraits
done by the artist.
Both the capacity to lay
bare the mind of the
model, and the clean
beauty of the pictorial
surface attract
our attention.
The secret and the magic
of Rembrandt's portraits
lies in just such
a transformation of the
visual appearance into
a vibrant chromatic
composition.

◆ PORTRAIT OF
NICOLAES BRUYNINGH
1652, Kassel,
Gemäldegalerie).
In this painting, the
vivacity and enthusiasm
of the model have been
manifestly transmitted by
the artist, who has
caught one of his best
expressive results.
Around the 1650's the
painter begins to
experiment with the
portrait of the seated
figure, and this one
of Bruyningh, who is
leaning forward in sweet
conversation, leaning on
an arm of the chair, is
the culminating moment
of these attempts.

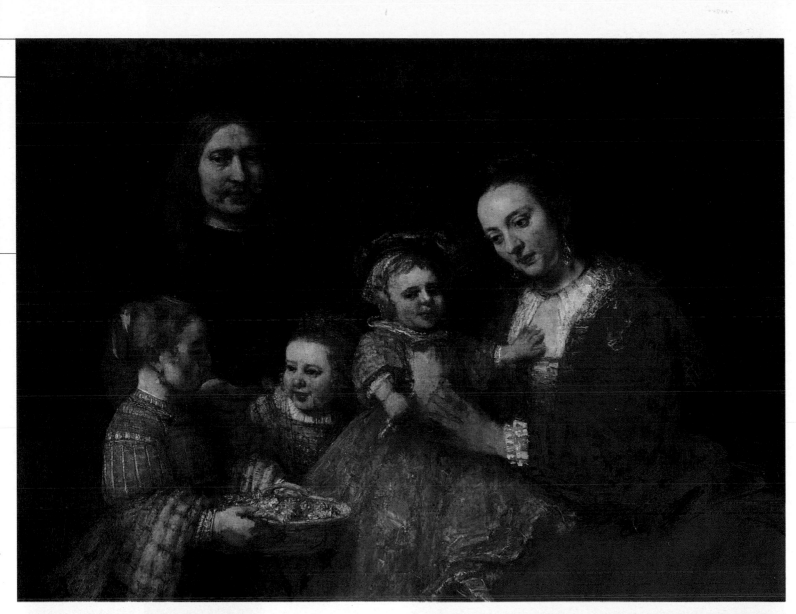

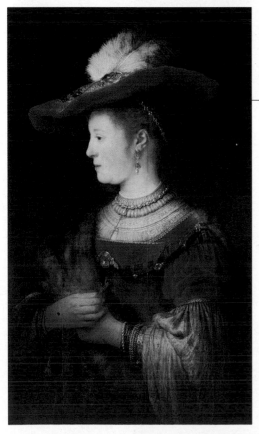

◆ PORTRAIT OF SASKIA
VAN UYLENBURGH
(1634, Kassel,
Gemäldegalerie).
In this portrait Saskia
appears dressed
with refined elegance,
wearing clothes inspired
by French fashion
and a charming
feathered hat.

◆ PORTRAIT OF TITO
READING
(1657 ca., Vienna,
Kunsthistorisches
Museum).
Tito, Rembrandt's son,
is about sixteen
years old here.
During the difficult
period of the artist's
bankruptcy, he was
of great comfort and
help to his father.

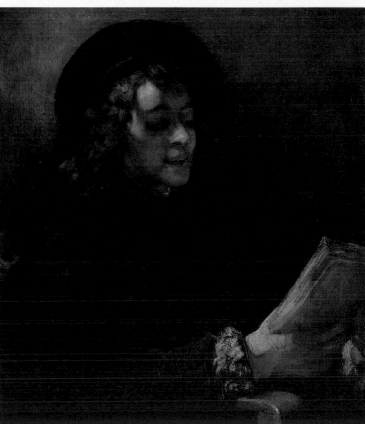

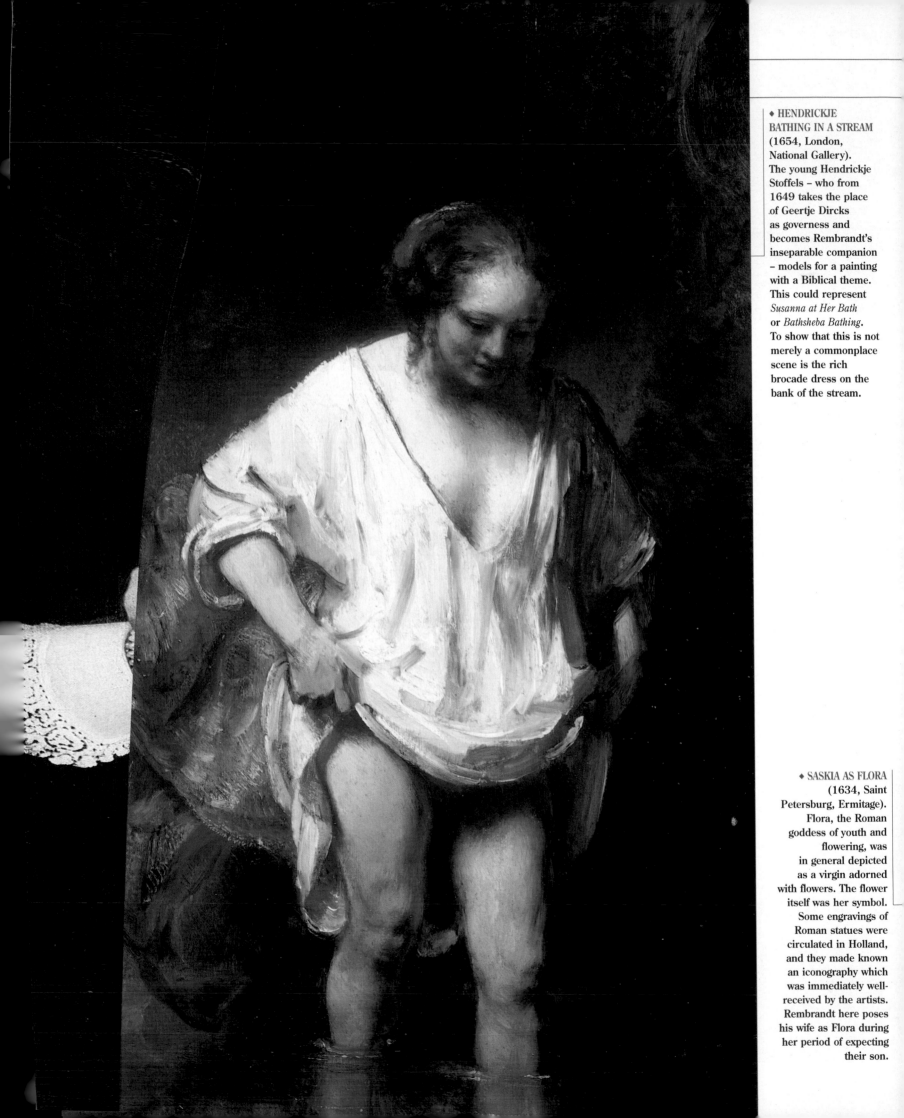

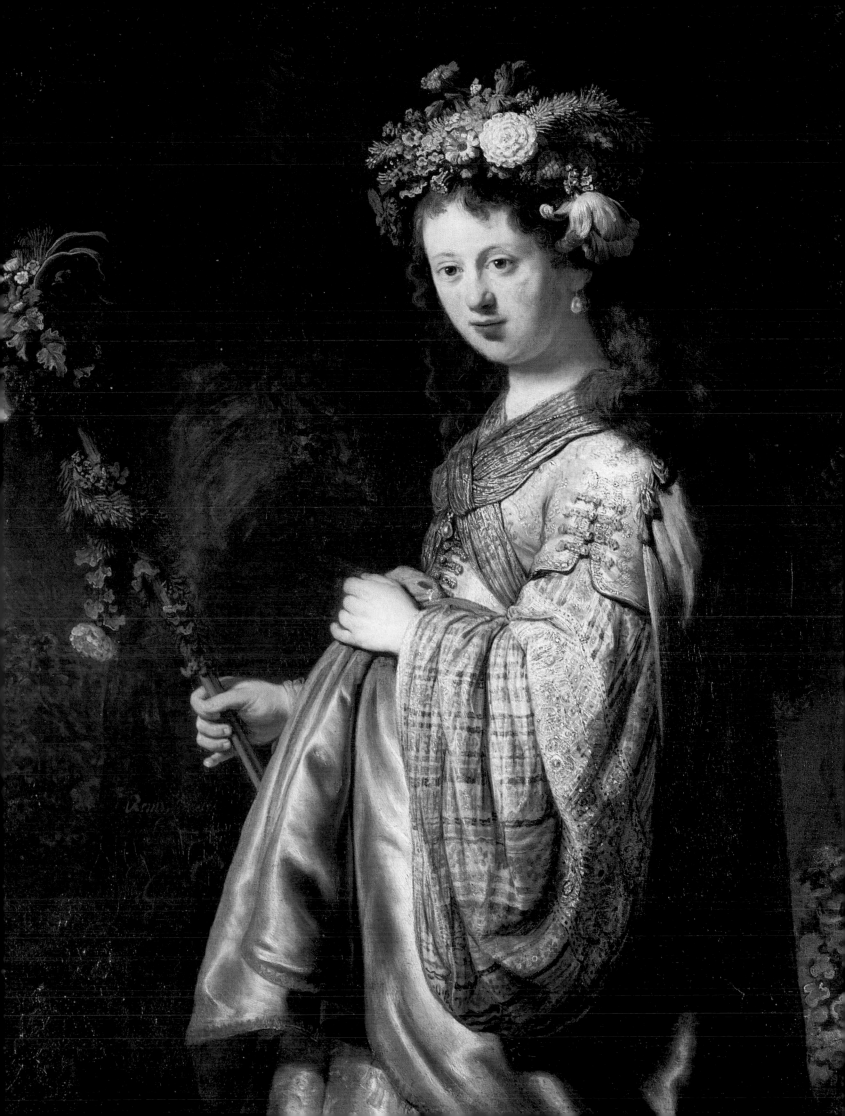

FACING THE BAROQUE

With the paintings of the commission for Frederick Henry – the valuable *Passion* cycle – Rembrandt feels that the moment to measure himself against the Flemish and Italian Baroque has arrived. Catholic paintings of large size are not often requested for the churches in the Reformed Low Countries, as happens instead in Italy, France and Spain. So, in order to deal with large dimensions, he must only hope for private commissions.

● The paintings for the *Passion* are once again small, but already indicate the measure of Rembrandt's potential, which will explode in successive years with the "grand style": from the *Sacrifice of Isaac* and the *Holy Family* of Munich, to the

Celebration of Balthazar, the splendid *Bathsheba With the Letter from David*, the *Jacob Blesses the Children of Joseph* and finally to the *Return of the Prodigal Son*.

● But alongside the grand size and New Testament predilections of his subjects, Rembrandt continues to produce in small size as well – for a decisively easier and more familiar market

♦ THE CELEBRATION OF BALTHAZAR (1635, London, National Gallery). The scene captures the moment in which the mysterious Hebrew writing appears on the wall.

– choosing from time to time subjects taken from the apocryphal books of Daniel and Tobias. He often gives life to mass scenes from the Bible, elaborating compositive schemes for these which open the entire pictorial space.

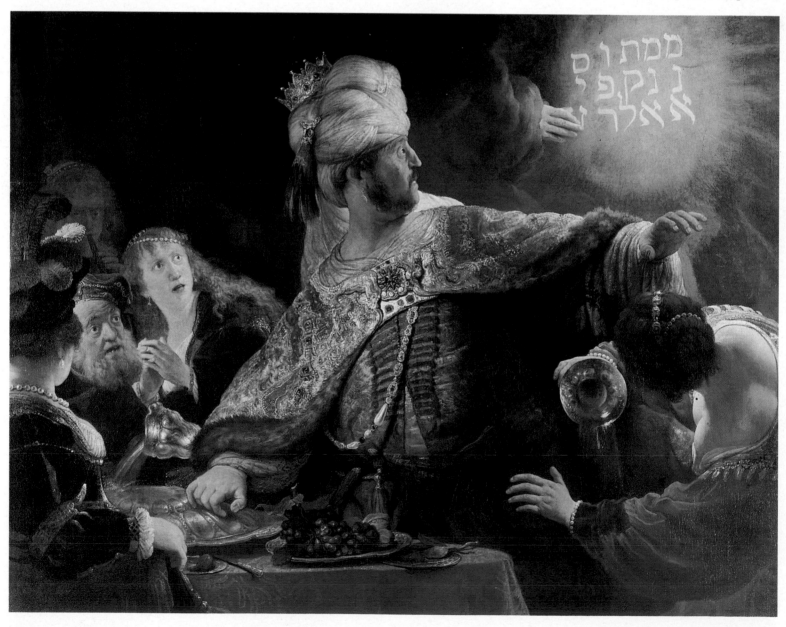

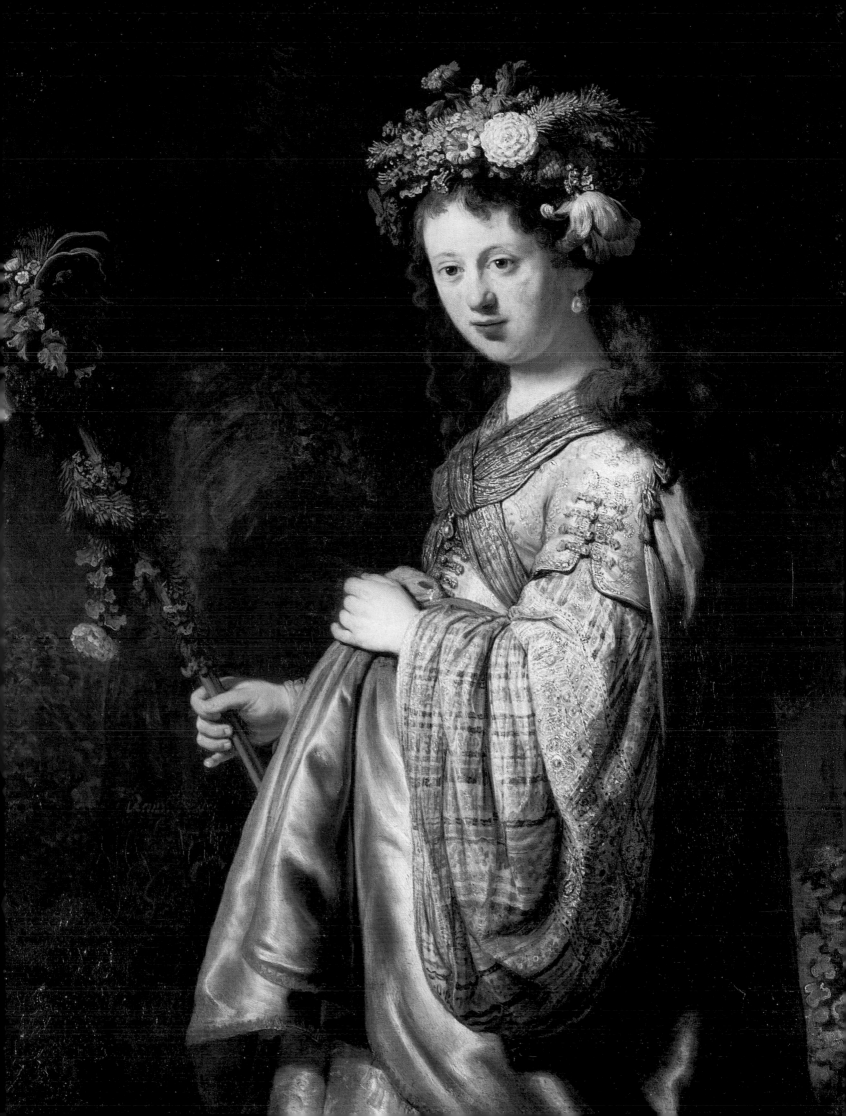

FACING THE BAROQUE

With the paintings of the commission for Frederick Henry – the valuable *Passion* cycle – Rembrandt feels that the moment to measure himself against the Flemish and Italian Baroque has arrived. Catholic paintings of large size are not often requested for the churches in the Reformed Low Countries, as happens instead in Italy, France and Spain. So, in order to deal with large dimensions, he must only hope for private commissions.

● The paintings for the *Passion* are once again small, but already indicate the measure of Rembrandt's potential, which will explode in successive years with the "grand style": from the *Sacrifice of Isaac* and the *Holy Family* of Munich, to the

Celebration of Balthazar, the splendid *Bathsheba With the Letter from David*, the *Jacob Blesses the Children of Joseph* and finally to the *Return of the Prodigal Son.*

● But alongside the grand size and New Testament predilections of his subjects, Rembrandt continues to produce in small size as well – for a decisively easier and more familiar market

♦ THE CELEBRATION OF BALTHAZAR (1635, London, National Gallery). The scene captures the moment in which the mysterious Hebrew writing appears on the wall.

– choosing from time to time subjects taken from the apocryphal books of Daniel and Tobias. He often gives life to mass scenes from the Bible, elaborating compositive schemes for these which open the entire pictorial space.

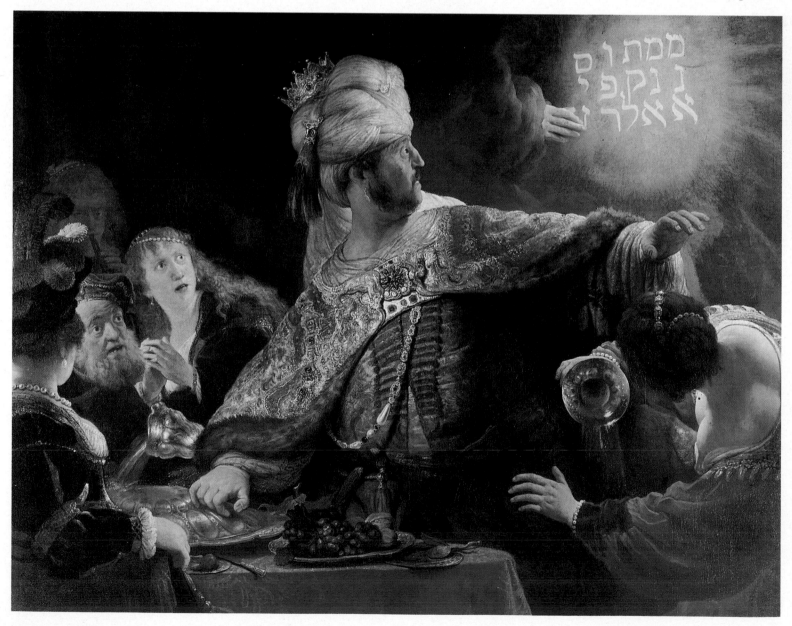

REMBRANDT

♦ DESCENT FROM THE CROSS

(1633 ca., Munich, Alte Pinakothek). This painting in Munich is part of the *Passion* cycle commissioned by the Stadtholder Frederick Henry. The scene is concentrated on the cross, which cuts obliquely across the plane, on the dead body of Christ, and on the faces and hands of the suffering, while below, the Virgin, fainted from her grief, is supported by two women. On the right, faithful to the Biblical text, is Nicodemus. The thematic model which inspires Rembrandt seems to be that of the *Descent from the Cross* by Peter Paul Rubens, portrayed on the Altarpiece of Antwerp in 1611-12, which the artist surely could have come to know through the reverse engraving of it drawn by Vorsterman. The cycle includes, in addition to this painting, the *Raising the Cross*, the *Laying to Rest in the Tomb*, the *Resurrection* and the *Ascension*, to which was later added the *Adoration of the Shepherds* and the *Circumcision*.

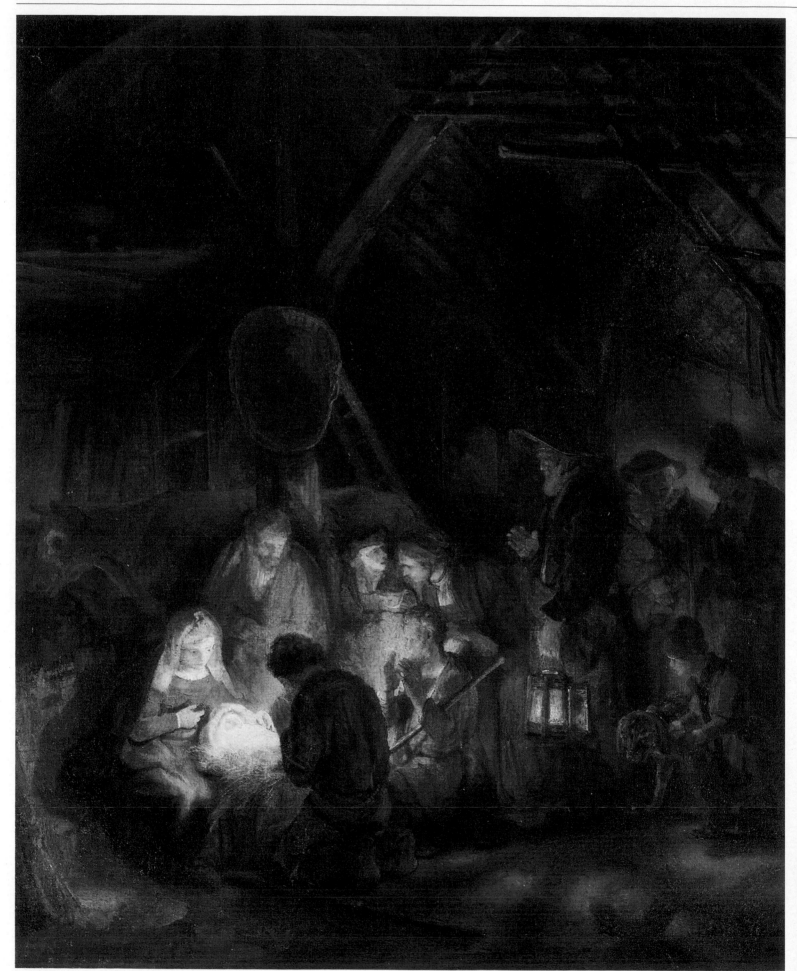

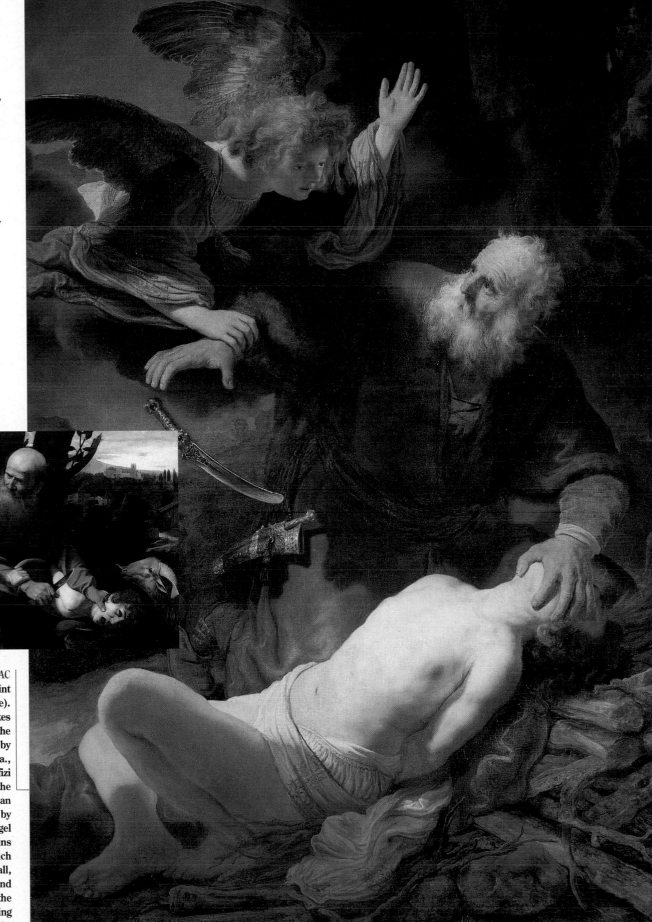

◆ ADORATION
OF THE SHEPHERDS
(1646, London,
National Gallery).
Rembrandt, unlike
other Dutch painters,
was not in the habit
of copying his works.
This painting, however,
is a minor version of
the analogous painting
in the *Passion* series.
The position of some
of the figures changes,
but on the whole
the structure of the
composition doesn't
undergo any particular
modifications.

◆ SACRIFICE OF ISAAC
(1635, Saint
Petersburg, Ermitage).
The realism here takes
up again that of the
Sacrifice of Isaac by
Caravaggio (1603 ca.,
Florence, Uffizi
Gallery), but the
structure is that of an
analogous work by
Lastman. The angel
violently restrains
Abraham's arm, which
lets the dagger fall,
while with his left hand
Abraham still covers the
face of his son, pushing
his head backwards.

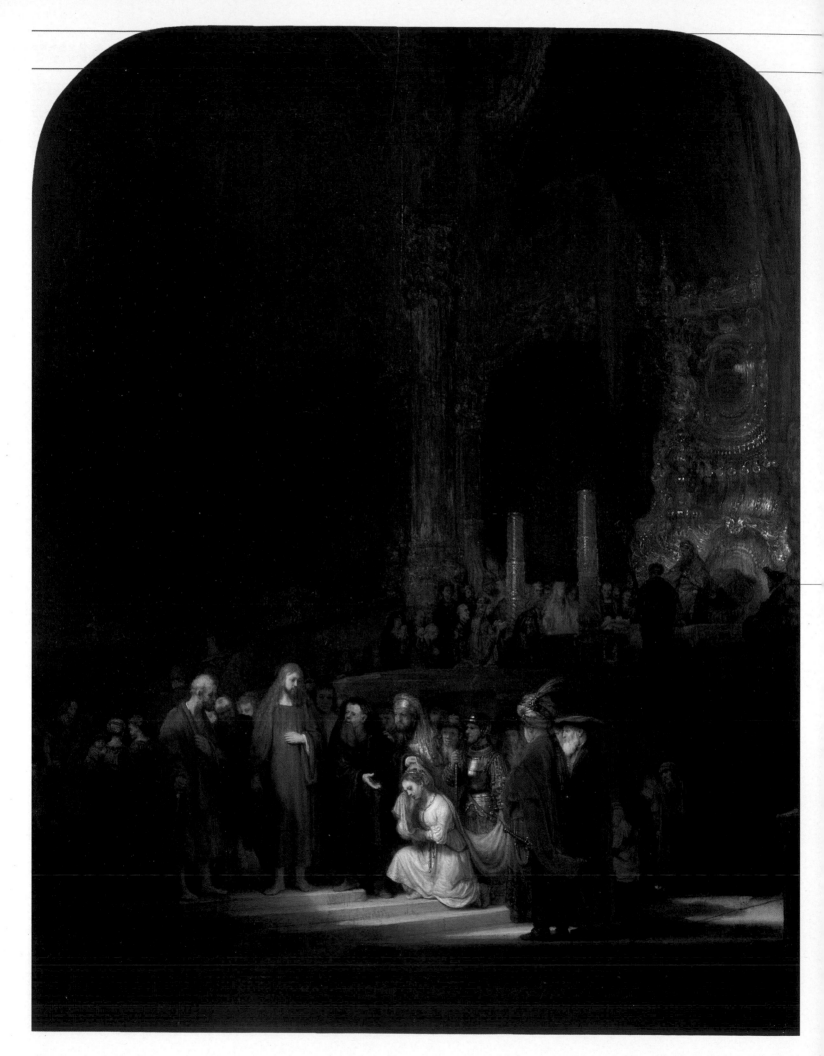

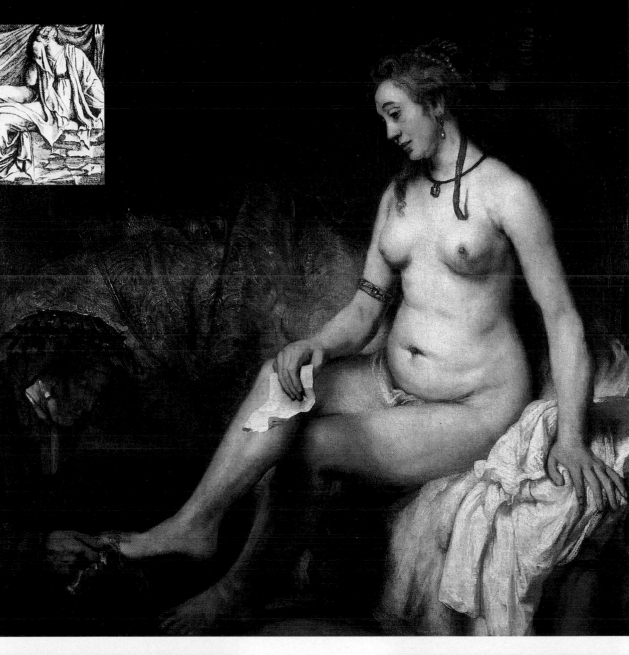

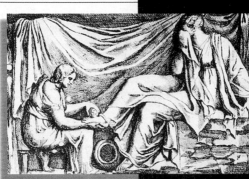

◆ BATHSHEBA WITH THE LETTER FROM DAVID (1654, Paris, Louvre). Bathsheba, knowing that David's passion will be the cause of her husband Uriah's death, is meditating on the letter of the King. The model for Bathsheba's pose is an engraving by Perrier (Rome, 1645, here, above) from an antique relief.

◆ CHRIST AND THE ADULTERESS (1644, London, National Gallery). For its pictorial vigor – the brushwork is more robust in the subjects in the foreground – and the dramatic concentration of the scene in a tight group of figures, this painting opens the way for the religious masterpieces created by the artist in the last twenty years of his production.

◆ PETER'S DENIAL (1665, Amsterdam, Rijksmuseum). The scene becomes particularly dramatic for the presence of Jesus in the background, who turns his head to witness the betrayal by Peter.

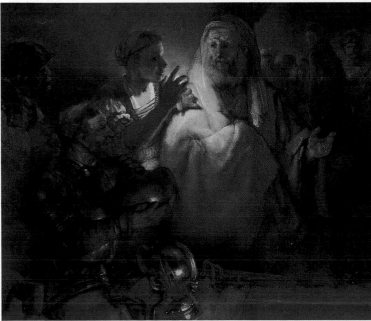

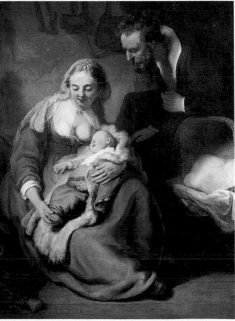

◆ HOLY FAMILY (1635, Munich, Alte Pinakothek). The painting captures the family in the privacy of Joseph's workshop, as the carpenter's tools hanging on the wall suggest.

IN FRONT OF ANTIQUITY

Rembrandt deals with the themes from antiquity only after his move to Amsterdam, learned and erudite center in which the circulation of the literary sources of history is documented from the 1400's.

● Without a doubt, the artist could consult the *Metamorphoses* of Ovid interpreted by Van Mander, *Ab Urbe condita libri* by Tito Livio and *Facta et dicta memorabilia* by Valerio Massimo.

● In his first paintings of history, Rembrandt articulates his compositions with great numbers of figures; then, he enlarges the figures, reducing the number of characters and increasing the dimensions of the canvas until he arrives at the single figure of natural size: practically a sort of portrait of historical figures.

● The artist's paintings at times remain mysterious and enigmatic, as in the case of the *Abduction of Ganymede*, in which the traditional iconography is completely ignored, and in the place of the comely youth abducted by Zeus to make the constellation of Aquarius, we find ourselves in front of a little baby boy who is screaming and peeing.

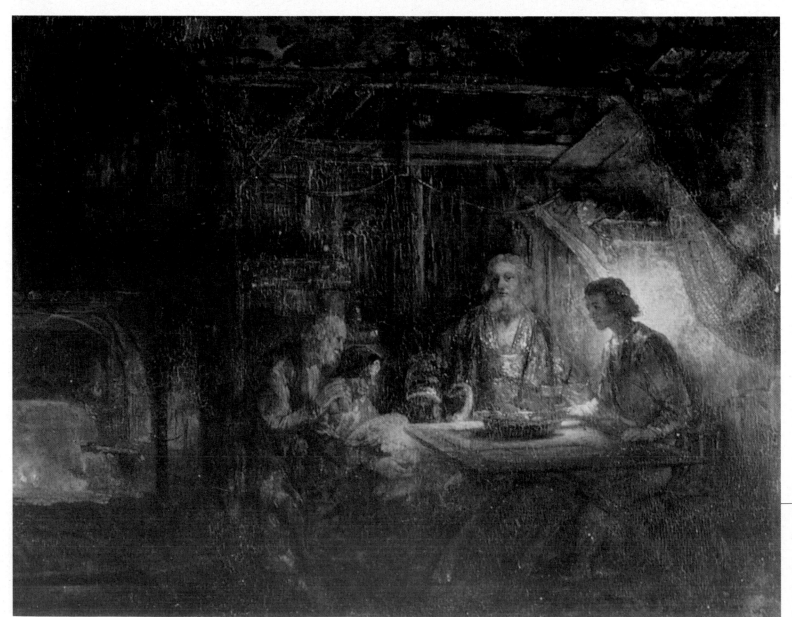

◆ ABDUCTION OF GANYMEDE
(1635, Dresden, Gemäldegalerie).
This interpretation of the myth has no analogous precedents: the victim of the abduction is a baby instead of a youth; the realism reserved for the reaction of the little one could allude to the subsequent location of Ganymede as cupbearer to the gods in the constellation of Aquarius. In that case the insistence on the liquid element would be a symbolic reference to the rain. The crying Ganymede recalls the *Crying Angel* of Dürer (1521 ca., Berlin, Staatliche Museen Preussischer Kulturbesitz, above).

◆ PHILEMON AND BAUCIS
(1658, Washington, D.C., National Gallery of Art).
This subject is rather unusual in Dutch painting. The episode, taken from the *Metamorphoses* of Ovid, comes from classical mythology, but it comes to be recognized as a source of Christian charity which attracts Rembrandt and his contemporaries.

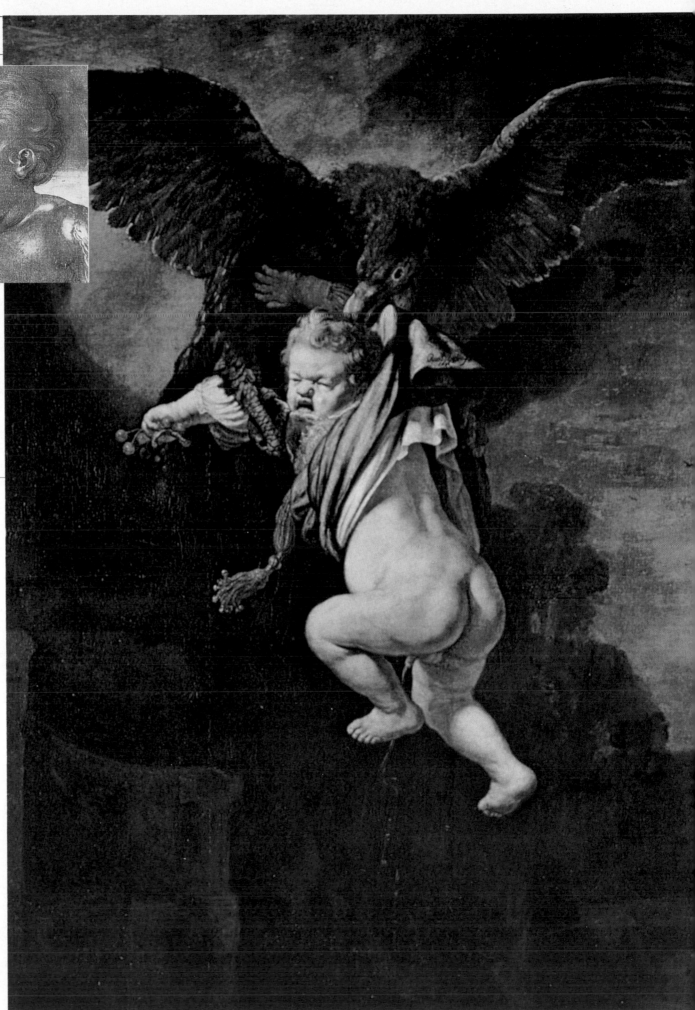

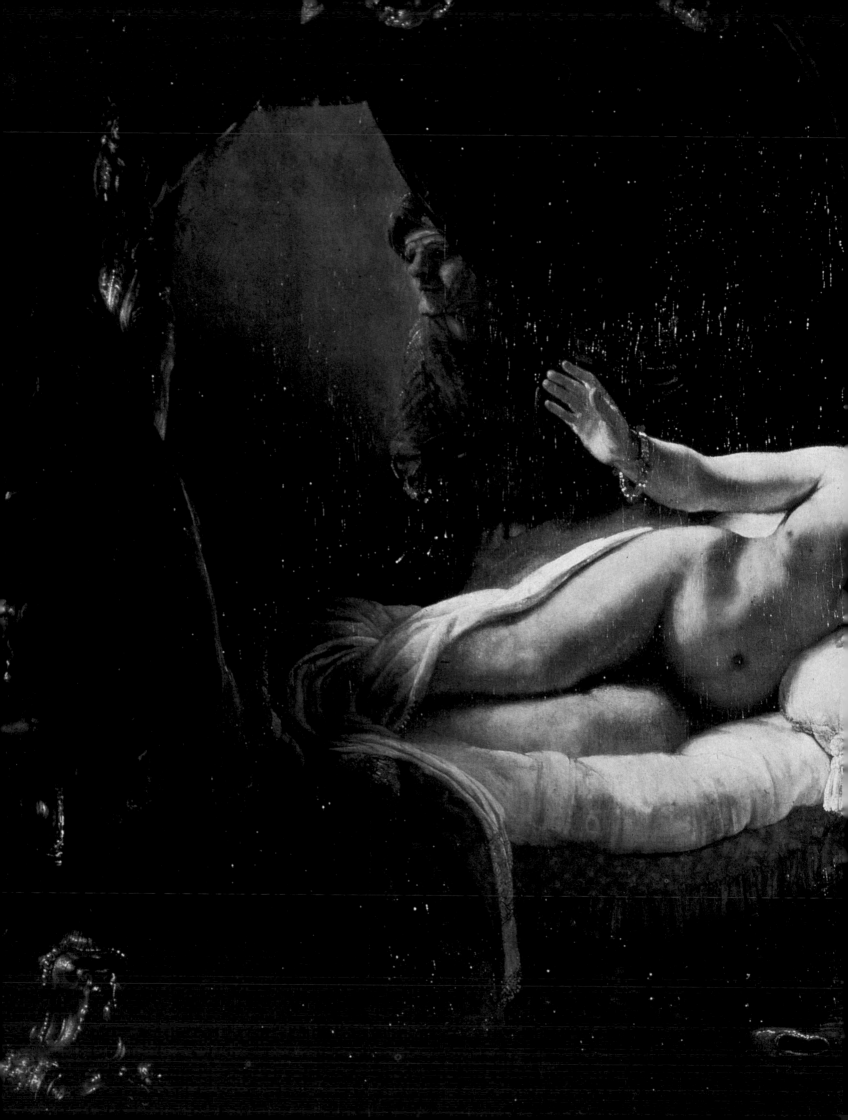

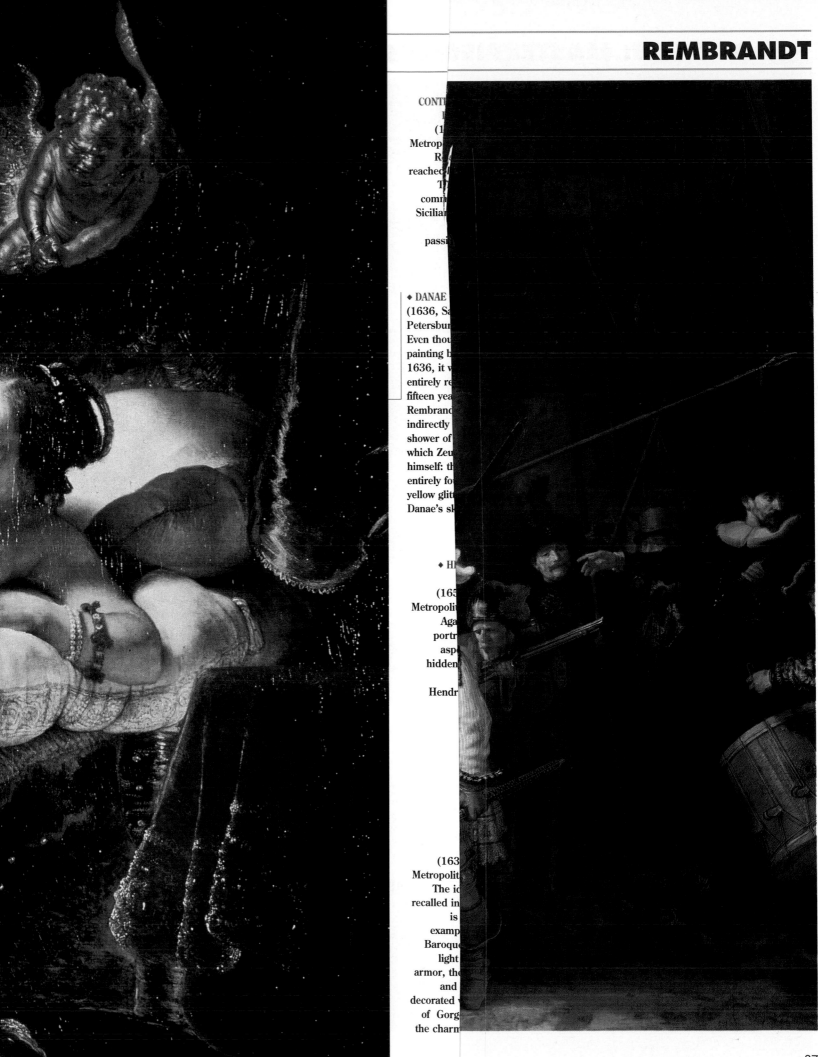

CONT

I
(1
Metrop
R
reached
T
comm
Sicilian

passi

♦ DANAE
(1636, Sa
Petersbur
Even thou
painting b
1636, it v
entirely re
fifteen yea
Rembran
indirectly
shower of
which Zeu
himself: th
entirely fo
yellow glit
Danae's sk

♦ H

(165
Metropoli
Aga
portr
aspe
hidden

Hendr

(163
Metropolit
The ic
recalled in
is
examp
Baroque
light
armor, the
and
decorated
of Gorg
the charm

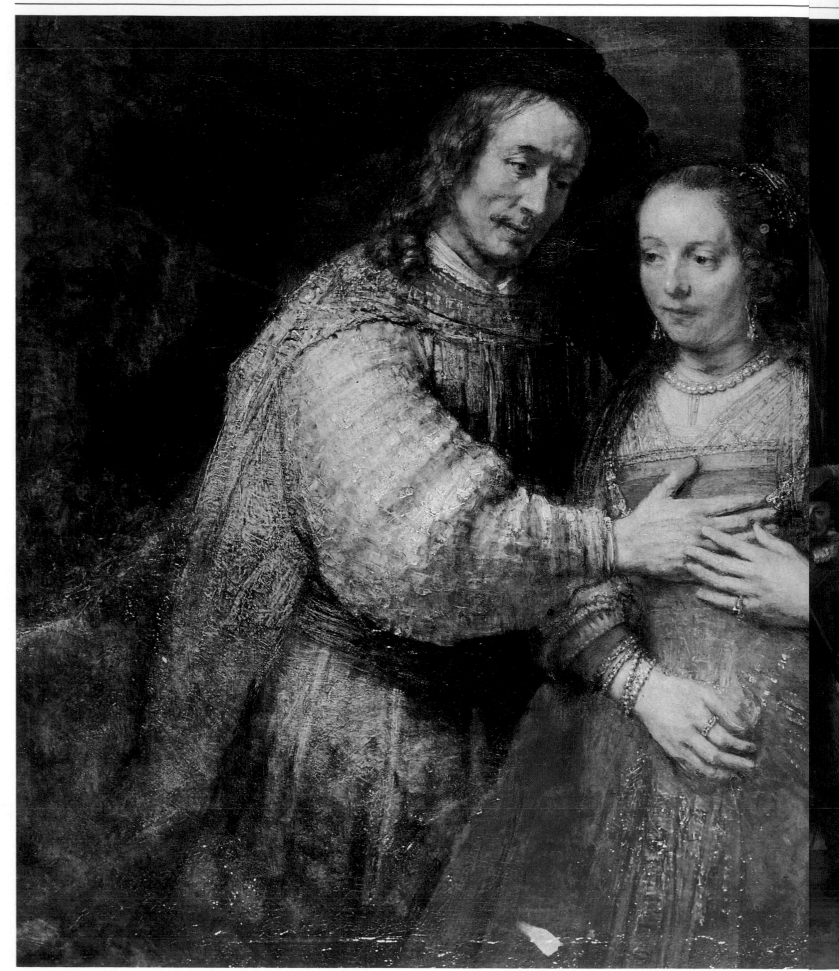

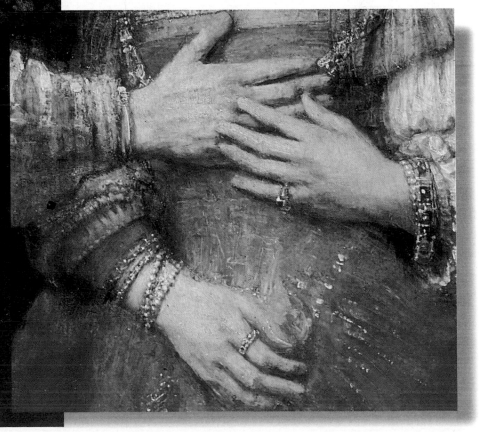

◆ THE HEBREW BRIDE (1660, Amsterdam, Rijksmuseum).
The title belongs to the tradition, but the identification of the theme is uncertain. According to the popular interpretation, it could be treating the Biblical scene of the marriage of Isaac and Rebecca, or a portrait of Tito, Rembrandt's son, with his wife, Magdalena van Loo. Without a doubt, the masterpiece constitutes one of the most beautiful depictions of love, expressed through the tenderness entrusted to the knowing play of the hands.
The bridegroom encircles the shoulders of the woman with his left hand, and innocently places his right hand on her chest, in a delicate embrace. The bride consents to the intimate gesture of the man, matching it with her left hand, while with her right she modestly touches her womb. The expression on the faces of the newlyweds shows their intimate emotion in a just lit smile, laden with complicity and trepidation from the exchange of tendernesses prefiguring the conjugal union.

PORTRAIT OF A RISING MIDDLE CLASS

In the first half of the 1600's, all of Europe is involved in a gigantic struggle for hegemony which witnesses, on the one hand, the blockade of the Hapsburgs, (the Empire and Spain), and on the other the array of German, Dutch, Danish and Swedish Protestant princes, with the support of France.

● Countries like England and the United Provinces orient their economic activity toward sea trade, and aim for the development of large private companies: the Dutch East India Company holds a monopoly on trade with the orient for twenty years.

● Amsterdam becomes a great international city, seat of a business exchange, lively cultural center. And the success achieved in every field is the proof of a middle class in strong ascent.

● Fully five universities flourish in all the territory. The United Provinces welcome refugees who there produce their most important works: this is the case with Comenius and Descartes.

● In the artistic field the stimulus of Rubens arrives, and artists such as Frans Hals and Vermeer, Van Goyen and Ruysdael are at work. In 1648, with the peace of Westphalia, the United Provinces are officially recognized, and reach the peak of their power. It will later be Cromwell, in 1651, to decree the end of their naval supremacy.

◆ **LUDOLF BACKHUISEN**
Squadron of the East India Company
(1610 ca., Paris, Louvre).
The painting immortalizes the glory of the East India Company on the seas.

◆ **JAN VERMEER**
The Soldier and the Laughing Girl
(1657 ca., New York, Frik Collection).
The painting takes on once again the poetical rhythm typical of Vermeer's narration.

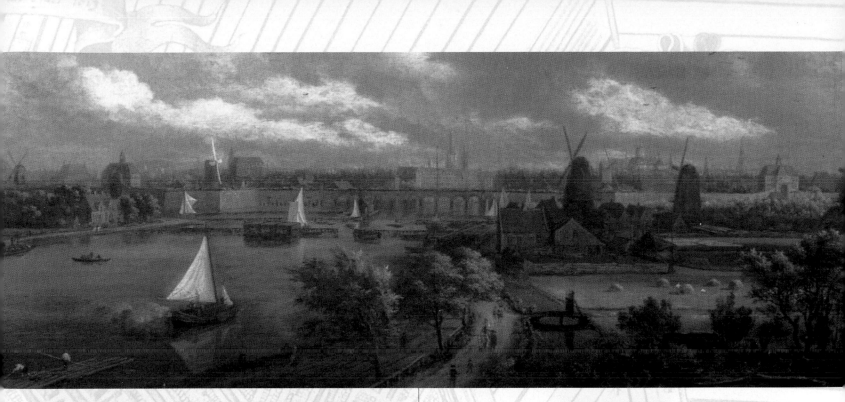

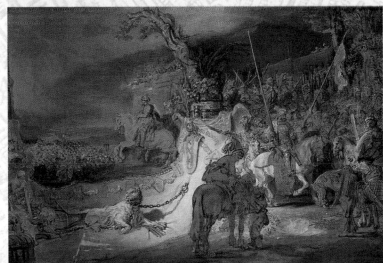

◆ JACOB ISAAKSZOON
VAN RUISDAEL
*View of Amsterdam
from the River*
Amsterdam of the
1600's is a city with an
extraordinarily intense
port, commercial and
cultural activity. The
poet Van den Vondel
writes of her that in the
city which "carries the
crown of Europe",
"resides the soul of the
State of Holland".

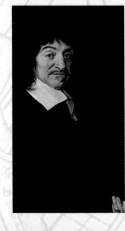

◆ FRANS HALS
Portrait of Descartes
(1640 ca., Paris,
Louvre).
Descartes writes of
Holland to his friend
Jean-Louis de Balzac:
"Which other country of
the world could you
choose, in which all the
conveniences of life,
and all the things of
interest that you could
want, be so easy to find
as in this one?"

◆ ALLEGORY OF THE
CONCORD
(1641, Rotterdam,
Museum Boymans-van
Beuningen).
The allegory is referring
to the constitution
of the Free United Low
Countries.

◆ PETER PAUL RUBENS
*Giusto Lipsius and his
Pupils*
(1611-12, Florence,
Pitti Palace).
A scene, loaded with
symbols, of one of the
most famous teachers
of the 1600's.

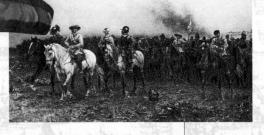

◆ ERNEST CROFTS
*Oliver Cromwell at the
Head of his Troops*
(19th century, Burnley,
Art Gallery).

Oliver Cromwell closes
the phase of Dutch
commercial splendor,
and confirms English
hegemony on the seas.

WIZARD AMONG WIZARDS

Rembrandt had, above all in the years between 1630 and 1640, a grand number of students, to whom he dedicated much of his time, in an atmosphere more academic than of a studio. Govaert Flinck, Gerrit Dou, Van Hoogstraten, Doomer, Carel Fabritius, Aert de Gelder are only some of his more important pupils, whom the painter accepts in his studio when they reach the age of thirteen or fourteen.

● Sandrart writes of his numerous disciples, and of how Rembrandt collects the fee of one hundred guilders from the apprentices, to whom he teaches nude figure drawing or casting in plaster. And the pupils themselves become confirmed artists and come to be requested almost as much as the master; for some decades, they perpetuate his manner, his style.

◆ GOVAERT FLINCK
Margaretha Tulp (1655, Kassel, Gemäldegalerie). After Rembrandt's financial crisis, some clients turn to his students instead of to the master: the Tulp family prefers to entrust the portrait of Margaretha to one of his best disciples, Govaert Flinck.

◆ GERRIT DOU
Woman Eating a Porridge of Oats (1632-37 ca.). Dou is among the best students of Rembrandt's studio, and is so close to the family of the master that the woman who models for this painting is Rembrandt's mother.

● But apart from this tangible and conspicuous immediate following, we cannot state that Rembrandt's teaching produced results even over the course of time. Loved and hated by his contemporaries, Rembrandt revolutionizes painting in wealthy seventeenth century Holland, knocks down the traditional canons, introduces new solutions of light and color, but in the course of twenty years is put aside. We will have to arrive at the 1800's before hearing him spoken of again with the enthusiastic tones of Delacroix or Van Gogh, who of his work above all love the exaggerated forms, the sense of mystery of "an earnestness that only he, wizard among wizards, possesses."

♦ **JACOB VAN RUYSDAEL**
Landscape with Shepherds and Farmers
(1660 ca., Florence, Uffizi).
Jacob van Ruysdael was, with Seghers and De Koninck, among the best landscape artists of the Dutch seventeenth century. He described with minute detail the surrounding environment, characterized by marshes, canals, and mills, immersed in storms, dark skies, and in the general unbridling of the elements.

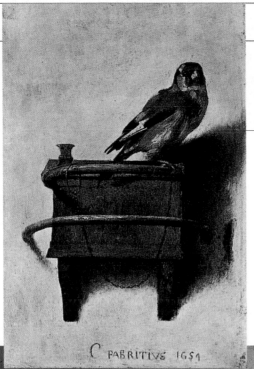

♦ **CAREL FABRITIUS**
The Goldfinch
(1654, L'Aja, Mauritshuis).
The painter inverts the effect of chiaroscuro, painting on unitary gray-white backgrounds.

♦ **GOVAERT FLINCK**
The Company of Captain Albert Base and Lieutenant Lucas Conijn
(1645, Amsterdam, Rijksmuscum).

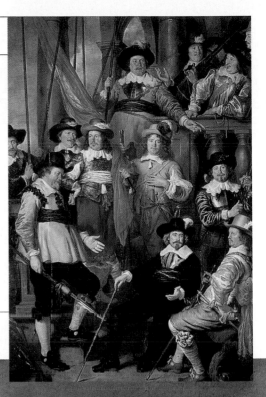

THE ARTISTIC JOURNEY

For a vision of the whole of Rembrandt's production, we propose here a chronological reading of his principal works.

◆ SELF-PORTRAIT (1628 ca.)
Rembrandt does more than sixty self-portraits, in which he experiments with new techniques and practices capturing the play of light on the face. This is the first: little more than twenty, he portrays himself in shabby clothes, with untidy hair and a slightly easy-going expression. The light is striking him from the side and even the background is vividly lit.

◆ THE PAINTER IN HIS STUDIO (1629 ca.)
The foreground is dominated by the easel, emblem of the painter, who squeezes a brush in his right hand and a palette, a spatula, and a group of brushes in his left. The light beats on the canvas at a great distance from the artist: with this, Rembrandt means to say that the painting must not be seen from up close, and must be placed in the right light to be able to recompose the whole from afar.

◆ SUPPER AT EMMAUS (1629)
The subject is painted in oil on paper, instead of canvas, later applied to wood. The luministic study is particular: the artist makes the most of the pictorial space as dramatic space, and the blinding light, which, even though coming from the figure of Christ illuminates him from behind, increasing the sensation of wonder and tension that is created in the surrounding setting.

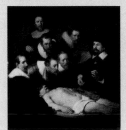

◆ PORTRAIT OF MOTHER (1631 ca.)
Neeltje (diminutive of Cornelia) van Suijttbroeck, Rembrandt's mother, belonged to the aristocracy of the city of Leiden; Harmen Gerritszoon, his father, miller of the fourth generation, descended from the wealthy middle class of the same center and owned a mill on the Rhine; from this came the name "van Rijn" (of the Rhine), which the family assumed as their surname from the artist's generation.

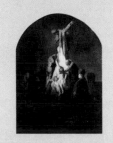

◆ ANATOMY LESSON OF DOCTOR TULP (1632)
The surgeon's guild of Amsterdam entrusts the painter with this important commission. This is one of the artist's first attempts in the field of group portraits. The composition is very innovative, both for the pose of the seven persons, which is no longer immobile and solemn, and for the study of their expressions, which no longer presents anything static and conventional.

◆ DESCENT FROM THE CROSS (1633 ca.)
This picture in Munich is part of a cycle of paintings of the *Passion*, commissioned by the stadtholder Prince Frederick Henry. The scene is concentrated on the cross, which cuts obliquely across the plane, on the dead body of Christ, and on the faces and hands of the suffering. Down below, the Virgin, fainted from her intense grief, is supported by two women. On the right, the artist places Nicodemus.

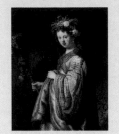

◆ SASKIA AS FLORA (1634)
Flora, the Roman goddess of youth and flowers, was in general depicted as a virgin adorned with flowers. The flower itself was her symbol. Some engravings of Roman statues were circulated in Holland, and they made known an iconography which was immediately well-received by the artists. Rembrandt here poses his wife as Flora during her period of expecting their son.

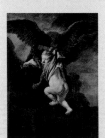

◆ ABDUCTION OF GANYMEDE (1635)
The depiction has no analogous precedent in the allegorical interpretations of the myth. For one thing the abducted is a baby boy instead of a youth; also new is the realism reserved for the reaction of the little one, who is crying and peeing. One could make allusion to the placement of Ganymede, cupbearer of the gods, within the constellation of Aquarius, who makes the rain pour copiously.

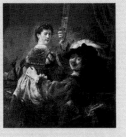

◆ REMBRANDT AND SASKIA IN THE SCENE OF THE PRODIGAL SON IN A BROTHEL (1635)
For years the painting was interpreted as a double portrait of the painter and his wife in a moment of extreme happiness. Then, the comparison with other paintings and designs of the same theme, and radiography performed on the canvas, have confirmed the hypothesis that we are speaking of the prodigal son who is squandering his patrimony in a brothel.

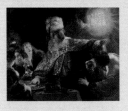

◆ THE CELEBRATION OF BALTHAZAR (1635)
This scene catches the moment in which the mysterious writing in Hebrew has just appeared on the wall, which has provoked a sudden change in the atmosphere among the onlookers. Balthazar, King of Babylon, bounds to his feet, upsetting his cup with a frightened and astonished air, as a woman on the right is also doing. In the astonished guest on the left we re-encounter the features of Saskia.

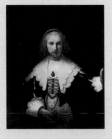

◆ PORTRAIT OF AGATHA BAS (1641)
Agatha Bas belongs to the Dutch upper-middle class. For this painting, Rembrandt breaks through the space, masterfully turning to a trompe-l'œil device already seen in Frans Hals: the woman rests her hand on the mock frame of the painting, cut by the open fan. The subject seems to step out into full light from surroundings immersed in semi-darkness.

◆ PORTRAIT OF CORNELIS CLAESZOON ANSLO AND HIS WIFE AALTJE GERRITSDR. SCHOUTEN (1641)
Rembrandt portrays Anslo as both the preacher and the cloth merchant. The Bible is open on the table, upon which rest two carpets, while his wife listens to the words of Holy Scripture chosen for her by her husband. The painter has once again preferred to capture a moment typical of the existence of the couple, portraying it in the intimacy of the home.

◆ ALLEGORY OF THE CONCORD (1641)

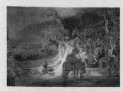

This painting in chiaroscuro is probably preparatory for an etching. The sense of the allegory, is anything but clear: perhaps it refers to the constitution of the Free United Low Countries. In the center, the coat of arms of the city of Amsterdam stands out, on the left is chained the enraged Belgian lion; the tree of Orange is silhouetted on the rock, the knights are pursuing different directions.

◆ NIGHT WATCH (1642)

The company of Captain Frans Banning Cocq is getting ready to fall in, while the two officers move toward the center, after having given the signal to march. The companies were usually portrayed in orderly lines or seated at table, so that a compositive solution such as this appeared altogether new. The fascination and effectiveness of the painting is exactly this dynamic unfolding of an action just begun.

◆ CHRIST AND THE ADULTERESS (1644)

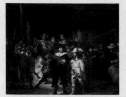

This is an unusual painting. In its compositive structure and the elaboration of the details, it goes back to preceding paintings, but its pictorial vigor – the brushwork is more robust in the subjects in the foreground – and the dramatic concentration of the scene in a tight group of figures, this painting opens the way for the religious masterpieces created by the artist in the last twenty years of his production.

◆ ADORATION OF THE SHEPHERDS (1646)

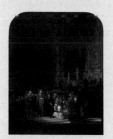

Differently from other Dutch painters of his time, Rembrandt only rarely replicated his own work. This picture is a smaller version of a painting from the *Passion* series, done for Frederick Henry. The position of the figures is changed, but on the whole, the organization of the scene has not undergone modifications. The miserable stable is illuminated from below by the light which emanates from Jesus.

◆ SUPPER AT EMMAUS (1648)

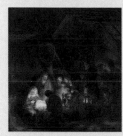

A comparison with the preceding painting of 1629 shows how much Rembrandt's art has matured in the meanwhile. Both pictures depict the moment in which Christ reveals himself to the two apostles, but while in the first the light and the attitudes confer a dramatic force to the scene, in this painting the gestures are more contained and the whole becomes more touching.

◆ SARAH WAITING FOR TOBIT (1648)

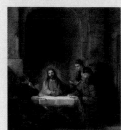

The theme is understood thanks to a comparison with an analogous painting by Pieter Lastman, Rembrandt's teacher. Sarah, in bed during her wedding night, is watching Tobit, who is burning ashes and performing ritual acts. The angel Raphael appears to drive away the devil, who in the preceding seven marriages of Sarah, killed her husbands before the wedding nights could be consummated.

◆ PORTRAIT OF NICOLAES BRUYNINGH (1652)

In this painting, the vivacity and enthusiasm of the model have been manifestly transmitted by the artist, who has caught one of his best expressive results. Around the 1650's the painter begins to experiment with the portrait of the seated figure, and this one of Bruyningh, who is leaning forward in sweet conversation, leaning on an arm of the chair, is the culminating moment of such attempts.

◆ BATHSHEBA WITH THE LETTER FROM DAVID (1654)

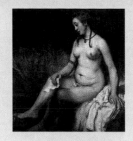

Bathsheba, conscious of the fact that David's passion will be the cause of her husband Uriah's death, meditates on the letter from the king, which she holds in her right hand, while the old woman servant dries her feet after her bath. The probable model for Bathsheba was the beautiful Hendrickje, but the formal model for the pose is an engraving by Perrier.

◆ HENDRICKJE BATHING IN A STREAM (1654)

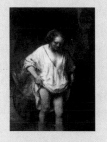

The young Hendrickje Stoffels, who from 1649 takes the place of the governess Geertje and becomes Rembrandt's companion, models for a painting with a Biblical theme. This could represent *Susanna at Her Bath* or *Bathsheba Bathing*. To show that this is not merely a commonplace scene is the rich brocade dress on the bank of the stream.

◆ THE ANATOMY LESSON OF DOCTOR DEYMAN (1656)

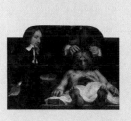

A fire breaking out in the anatomical theatre in 1723 partially destroyed the second anatomy lesson painted by Rembrandt, which we know in its general form from one of his own sketches. The iconographic debt for the dead body seems to be that of *Cristo morto* by Mantegna, to mean that even the executed man is created in the Divine image.

◆ SYNDICS OF THE DRAPERS' GUILD (1662)

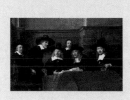

The canvas was destined for the Council of the Syndics of the Drapers' Guild. The commission united syndics of different religious confessions, seated at the same table in fraternal harmony, to underline the power of trade and the tolerance which reigned in Amsterdam in the so-called golden century. The figure of the servant had various locations in the preparations.

◆ THE HEBREW BRIDE (1660)

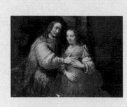

The title belongs to the tradition, but the identification of the theme is uncertain. According to the popular interpretation, it could represent the Biblical scene of the marriage of Isaac and Rebecca, or a portrait of Rembrandt's son Tito with his wife. Undoubtedly the masterpiece is one of the most beautiful depictions of love, expressed through the tenderness entrusted to the knowing play of the hands.

◆ SELF-PORTRAIT LAUGHING (1667-68)

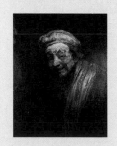

Some critics have advanced the hypothesis, rather convincing, that the painting could be the fragment of a larger work, in which Rembrandt meant to portray himself in the clothes of Zeuxis, the Greek painter who died suffocated by laughter while painting a comic, wrinkly old woman. To confirm the hypothesis, there is the revival of the theme by Aert de Gelder, the last disciple of the artist.

◆ FAMILY PORTRAIT (1668-69)

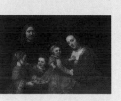

This group portrait depicts Rembrandt's family as it was made up at the end of his life. Appearing are: the widow of Tito, with her little daughter Tizia; the woman's brother-in-law with his son and Cornelia, born from the union of the artist with Hendrickje Stoffels. The colors of the painting appear slightly thinned from an antique restorative recanvasing, but the thick and mellow colors didn't suffer from it.

TO KNOW MORE

The following pages contain: some documents useful for understanding different aspects of Rembrandt's life and work; the fundamental stages in the life of the artist; technical data and the location of the principal works found in this volume; an essential bibliography.

DOCUMENTS AND TESTIMONIES

A Precious Inventory

In 1656, on the 25th and 26th of July, an itemized inventory was drawn up of the goods contained in the home of Rembrandt van Rijn, resident of Amsterdam on Sint Anthonies Breestraat. The artist's financial crisis had arrived at an incurable level, and there remained no other way but to declare bankruptcy. All the inventoried goods were put up for auction in order to realize the necessary capital for paying his debts. The great collection was thus dispersed in three successive auctions, and still the objective was not reached. We report here only some excerpts from the inventory, which sheds light on some of the curiosities in Rembrandt's encyclopedic collection.

"Series of books on art. [...]
195. Book with copperplates by Vanni and Baroccio;
196. The same with copperplates by Raphael of Urbino [...];
199. The same with drawings by the greatest masters in the world;
200. Precious book of etchings by Andrea Mantegna;
201. Large book as above, containing drawings and prints by many masters [...];
204. The same with prints by Brueghel the Elder;
205. The same with prints by Raphael of Urbino;
206. Prints by the same, of great value;
207. The same with prints by Antonio Tempesta;
208. The same, containing prints by Luca Cranach, both xylographs and copperplates;
209. The same, by Annibale, Agostino and Ludovico Carracci, Guido Reni and Spagnoletto [...];
216. Another very large book, containing almost all the works of Titian [...];
226. Book with copperplates of statues [...];
230. The same, containing all the work of Michelangelo Buonarroti [...];
273. The Book of Proportions by Albrecht Dürer, with xylographs [...];
284. A Giuseppe Flavio in German, with the figure of Tobias Stimmer".

A Chiaroscuro Portrait of Rembrandt

The witty pen of Filippo Baldinucci leaves us a very amusing portrait of "Rembrante", that brings to light above all the extravagance of his habits and his collection.

"This painter, being of a different mind from other men in the governing of himself, was thus also highly eccentric in his way of painting, and he did it in such a manner, one can say entirely his own, without internal or external outlines, all done with dashed and repeated strokes, with great strength of dark in its own way, but without deep darkness. And what makes him almost impossible to understand is: how he could, with such strokes, work so slowly and do things at such length and with such painstaking care, like no one ever before. He could have done a great quantity of portraits, to his great credit, because his coloring was in high demand in those parts, although it hardly matched his drawings; but it being common knowledge, that whoever wanted to be painted by him, would need to pose for a good two or three months, while he worked on it, few made the attempt. [...] The rest of Rembrante's life kept up with his extravagance of manner, because he was a humorist of the first class, and looked down on everybody. He would cut a bad figure, making ugly, common faces, wearing abject, filthy clothes, and being his working clothes, he would clean his brushes on them, and do other things, cut to the same measure. When he was working, he wouldn't grant audience to the greatest monarch in the world, who would need to come back and back again, until he found him to be unoccupied. He often visited public auctions: and there he would buy old and discarded clothing, because it seemed to him bizarre and picturesque: and after a while, when they would become truly filthy, he would stick them to the wall of his studio, among his beautiful treasures, which he also delighted in owning: to mention a few, every sort of antique and modern arm, such as arrows, halberds, daggers, sabers, knives and the like: innumerable quantities of exquisite drawings, prints, and medals, and any other thing, that you would never think a painter needed. [...] He was also very liberal in lending these things of his to any painter, to do whatever work they needed. One thing, truly worthy of this craftsman, was a very strange way, which he invented to etch into copper with nitric acid, again this his own, never again seen or used by others, with certain strokes and lines, and irregular features without borders, bringing about a result, however, of profound chiaroscuro and great strength. And to tell the truth, in this particular of engraving, Rembrante was more highly esteemed by professors of art than in painting, in which it seems that he had more singularity of fortune than excellence. In his engravings, moreover, he was used to note with badly composed, formless and dashed letters, the word Rembrandt. With these engravings he came to have great wealth, in proportion to which grew his haughtiness and high view of himself, that it then seemed to him that his cards were no longer selling for the price they deserved; he thought to find a way to have the desire for them grow universally; and with intolerable expense, he had them bought back from throughout Europe, wherever they could be found, at any price [...]. Finally, with such a great fabrication, his wealth diminished so much that he was reduced to the extreme: and it happened to him that which is seldom said of other painters, that he went bankrupt [...]."

[F. Baldinucci, *Notizie de' professori di disegno da Cimabue in qua*, Florence, 1686]

Rembrandt according to Van Gogh

Van Gogh seems to be attracted above all to the magic and mystery of the works of Rembrandt, of whom he speaks with the deference of a neophyte before the mastery of a great magician.

October 1885

"*The Syndics of the Drapers' Guild* is perfect: it is one of the most beautiful Rembrandts; but *The Hebrew Bride* [...] never has there been a painting so intimate, brimming with infinite understanding, painted *d'une maire de feu*. You see, in *Syndics*, Rembrandt is faithful to nature, although, even here, as always, he is soaring high, toward the highest summits and infinity; but Rembrandt knew how to do more [...] when he was free to idealize, to be a poet, that is to say Creator. And this is what he is in *The Hebrew Spouse*. [...] *Il faut être mort plusieurs fois pour peindre ainsi, (one has to die many times to paint like this)*, as is true in this case. As for the paintings of Frans Hals – he will always remain a mortal – to those, words can be addressed. Rembrandt is so full of mystery to say things that cannot be expressed in any language. Rembrandt is quite rightly defined a magician... it is not easy to be one. [...]"

December 1885

"[...] Yesterday I say a large photograph of a Rembrandt that I hadn't known, and it struck me very deeply: it was the head of a woman, the light was falling on her bust, neck, head, on the point of her nose and on her jaw. Her forehead and eyes were in shadow because of her large hat, with feathers most likely red. Perhaps there is also red in her low-necked jacket. A dark background. The expression is that same mysterious smile of Rembrandt found in his self-portrait in which he is seated with Saskia on his knees, and a glass of wine in his hand. These days my thoughts are continually turning to Rembrandt and Frans Hals, not only because I am seeing many of their pictures, but because among the people here I see many types that remind me of their time. I am still going often to those popular dances, to see the heads of the women of the sailors and soldiers. [...] I know that you are rather convinced of the importance of being realistic, so I can speak to you freely. If I paint farmers, I want them to be farmers; [...] if I paint prostitutes, I want that they have a prostitute's expression. It is for this that the head of one of Rembrandt's prostitutes struck me so much. Because he grasped their mysterious smile in such a marvelous way, with an earnestness that only he, wizard among wizards, possessed. [...]"

HIS LIFE IN BRIEF

1606. Rembrandt is born on July 15th in Leiden. He is the son of Neeltje van Suijttbroeck and Harmen Gerritszoon, miller and owner of a mill, on the Rhine, from which the name Van Rijn is derived.

1613. He attends the Latin School of Leiden.

1621-23. He is apprenticed to the painter Jacob van Swanenburgh.

1623. He moves to Amsterdam and attends the atelier of Pieter Lastman.

1625. Returns to Leiden and opens an atelier with Jan Lievens, which will be attended by many pupils.

1630. His father dies.

1631. Noted by Huygens, he moves to Amsterdam, associating with the art dealer Uylenburgh.

1634. Marries Saskia van Uylenburgh, receives the Stadtholder's commission, and joins the Guild of Saint Luke.

1635-39. Moves onto Niewdoelenstraat, has many pupils; his daughter Cornelia is born, and dies. He moves again, onto S. Anthonies Breestraat.

1640. His mother dies. Another daughter by the name of Cornelia is born, and does not survive.

1641. His son Tito is born.

1642. He paints the *Night Watch*; Saskia dies.

1649. The lawsuit begins between Geertje Dircks, Tito's wet nurse, and Rembrandt, accused of breach of promise. He begins living together with Hendrickje Stoffels.

1653. His serious financial failure begins.

1654. The ecclesiastical court summons Rembrandt and Hendrickje, accusing them of concubinage. Cornelia is born, daughter of Hendrickje. Creditors are insistently knocking at Rembrandt's door; his works do not seem to reflect the grave scandal and the financial crisis.

1655. The painter's appraisals drop.

1656. Rembrandt is forced to declare bankruptcy. He tries to bequeath the house to his son without success. An inventory of his wealth is drawn up.

1657-58. The goods are sold in three auctions, but the earnings do not cover the debt.

1660. Draws up a contract with Tito and Hendrickje in which he commits himself to work only for them in exchange for room and board.

1663. Hendrickje Stoffels dies in July.

1667. Cosimo de' Medici visits Rembrandt's studio.

1668. Tito marries Magdalena van Loo, niece of Saskia's sister, but dies in the month of September. At the end of the year his daughter Titia is born.

1669. Rembrandt dies on October 4th, and after some days his daughter-in-law Magdalena.

WHERE TO SEE REMBRANDT

The following is a listing of the technical data for the principal works of Rembrandt that are conserved in public collections. The works are ordered according to the cities in which they are found. The data contain the following elements: title, dating, technique and support, size expressed in centimeters.

HAMBURG (GERMANY)
Portrait of Mother, 1631 ca.; etching, 129x146; Kunsthalle.

AMSTERDAM (HOLLAND)
Self-Portrait, 1628 ca.; oil on wood, 18.7x22.6; Rijksmuseum.

The Syndics of the Drapers' Guild, 1662; oil on canvas, 279x191.5; Rijksmuseum.

The Denial of Peter, 1665; oil on canvas, 169x154; Rijksmuseum.

The Hebrew Bride, 1660; oil on canvas, 166.5x121.5; Rijksmuseum.

Anatomy Lesson of Doctor Deyman, 1656; oil on canvas, 134x100; Rijksmuseum.

Night Watch, 1642; oil on canvas, 437x363; Rijksmuseum.

BERLIN-DAHLEM (GERMANY)
Portrait of Cornelis Anslo and his Wife, 1641; oil on canvas, 210x176; Staatliche Museen Preussischer Kulturbesitz.

Saskia with a Big Hat, 1633; silverpoint on white-washed parchment, 107x185; Staatliche Museen Preussischer Kulturbesitz.

BOSTON (UNITED STATES)
The Painter in his Studio, 1629 ca.; oil on wood, 31.9x25.1; Museum of Fine Arts.

BRAUNSCHWEIG (GERMANY)
Family Portrait, 1668-69; oil on canvas, 167x126; Herzog Anton Ulrich Museum.

COLOGNE (GERMANY)
Laughing Self-Portrait, 1668 ca.;
oil on canvas, 65x82.5;
Wallraf-Richartz-Museum.

COPENHAGEN (DENMARK)
Supper at Emmaus, 1648;
oil on canvas, 111.5x89.5;
Staatens Museum for Kunst.

DRESDEN (GERMANY)
Abduction of Ganymede,
1635; oil on canvas, 130x177;
Gemäldegalerie.

Rembrandt and Saskia in the Scene of the Prodigal Son, 1635; oil on canvas, 131x161; Gemäldegalerie.

EDINBURGH (SCOTLAND)
Sarah Waiting for Tobit, 1648;
oil on canvas, 27.9x81.2; National Gallery
of Scotland.

KASSEL (GERMANY)
Jacob Blessing the Sons of Joseph,
1656; oil on canvas, 210.5x175.5;
Gemäldegalerie.

Portrait of Nicolaes Bruyningh,
1652; oil on canvas, 91.5x107.5;
Gemäldegalerie.

L'AJA (HOLLAND)
Anatomy Lesson of Doctor Tulp, 1632;
oil on canvas, 216.5x169.5; Mauritshuis.

LONDON (ENGLAND)
Adoration of the Shepherds, 1646;
oil on canvas, 55x65.5; National Gallery.

Self-Portrait with Palette, 1661;
oil on canvas, 94x114.3; Kenwood House,
Iveagh Bequest.

Christ and the Adulteress, 1644;
oil on wood, 65.4x83.8;
National Gallery.

Hendrickje Bathing in a Stream, 1654;
oil on wood, 47 x 61.8; National Gallery.

The Celebration of Balthazar, 1635; oil
on canvas, 209.2x167.6; National Gallery.

Portrait of Agatha Bas,
1641; oil on canvas, 83.9x105.2;
Buckingham Palace, Royal Collection.

LOS ANGELES (UNITED STATES)
Portrait of Marten Looten, 1634;
oil on canvas, 74.9x92.87; Country
Museum of Art.

MADRID (SPAIN)
Artemisia, 1632; oil on wood, 153x142;
Museo del Prado.

MUNICH (GERMANY)
Descent from the Cross, 1633 ca.;
oil on wood, 65.2x89.4; Alte Pinakothek.

Holy Family, 1635 ca.; oil on canvas,
123.5x183.5; Alte Pinakothek.

NEW YORK (UNITED STATES)
Aristotle Contemplating the Bust of Homer, 1653; oil on canvas, 136.5x143.5;
Metropolitan Museum of Art.

PARIS (FRANCE)
Bathsheba with the Letter from David,
1654; oil on canvas, 142x142; Louvre.

Supper at Emmaus, 1629; oil on paper
applied to wood, 42.3x37.4; Musée
Jacquemart-André.

Supper at Emmaus, 1648; oil on wood,
65x68; Louvre.

Supper at Emmaus, 1660; oil on wood,
48x64; Louvre.

ROTTERDAM (HOLLAND)
Allegory of the Concord, 1641; oil on
wood, 100x74.6; Museum Boymans-van
Beuningen.

Tito Studying, 1655; oil on canvas, 63x77;
Museum Boymans-van Beuningen.

SAINT PETERSBURG (RUSSIA)
Danae, 1636; oil on canvas, 203x185;
Ermitage.

The Return of the Prodigal Son,
1667-68; oil on canvas, 206x262; Ermitage.

Sacrifice of Isaac, 1635; oil on canvas,
132.5x193; Ermitage.

Saskia as Flora, 1634; oil on canvas,
100.4x124.7; Ermitage.

WASHINGTON, D.C. (UNITED STATES)
Portrait of the Lady with the Ostrich-Feather Fan, 1660 ca.; oil on canvas,
83x99.5; National Gallery of Art.

BIBLIOGRAPHY

The bibliography on Rembrandt is copious, and only a small part is translated into Italian. Only some essential indications are furnished in the following list, useful for gaining the first instruments of orientation and information. To have a repertory of significant and timely studies, consult the bibliography edited by E. Haverkamp-Begemann, in the *Enciclopedia Universale dell'Arte*, vol. XI, under the heading "Rembrandt". In addition, there is now being printed the general catalogue of the whole of Rembrandt's work, edited by the Foundation Rembrandt Research Project.

1963 K.G. Boon, *Rembrandt. Incisioni, opera completa*, Milano

1967 G. Huizinga, *La civiltà olandese del Seicento*, Torino

1969 B. Haack, *Rembrandt, la sua vita, la sua opera, il suo tempo*, Milano
L. Puppi, *Rembrandt*, Firenze

1973 O. Benesch, *The Drawings of Rembrandt*, London
J. van Loon, *Vita di Rembrandt van Rijn*, Treviso

1978 P. Lecaldano, *L'opera pittorica completa di Rembrandt*, Milano

1980 C. Brown, *Rembrandt*, Milano

1988 C. White, *Rembrandt*, Milano

1990 S. Alpers, *L'officina di Rembrandt*, Torino

1991 C. Brown, J. Kelch, P. van Thiel, *Rembrandt. Il maestro e la sua bottega*, Catalogue of the Exhibition of Berlin-Amsterdam, London-Roma
C. Tümpel, *Rembrandt*, Milano

1992 D.D. van Dongen, M. Tazartes, *Rembrandt*, in "Art Dossier", n. 65
L. Slatkes, *Rembrandt*, Complete Catalogue, Firenze

1993 P. Bonafoux, *Rembrandt. L'ombra e la luce*, Paris-Milano

1995 C. Pescio, *Rembrandt e la pittura olandese del XVII secolo*, Milano

1996 M. Tazartes, *Rembrandt*, Firenze